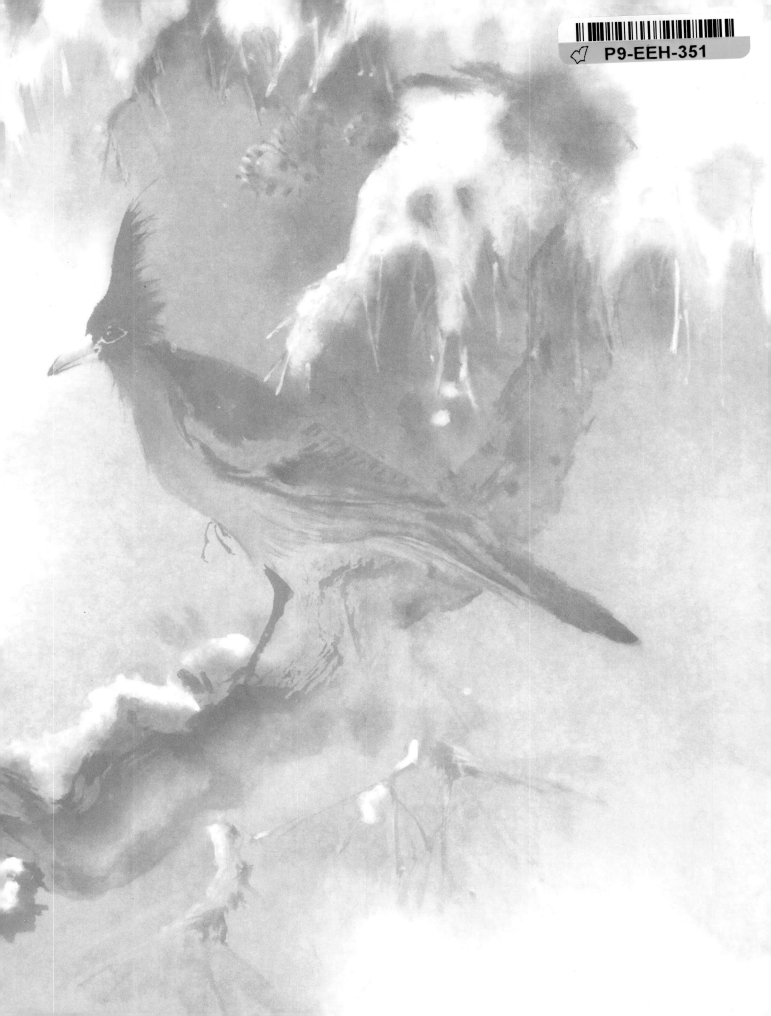

Snow Painting

CHINESE BRUSH PAINTING

Snow Painting

CHINESE BRUSH PAINTING

Rosemary Reed

PUBLISHERS DESIGN GROUP

Publishers Design Group
Rights Department
P.O. Box 37
Roseville, CA 95678
books@publishersdesign.com

To order individual books or Fine Art reproductions of paintings, visit the web site
at www.rosemary-art.com, or call 866-711-7005. Publishers Design Group titles
published under the imprint of PDG are distributed to the book trade through Biblio
Distribution, located in Lanham, MD 20706.

LCCN: 2005925010
ISBN: 1-929170-15-7
ISBN: 978-1-929170-15-9

Original text and demonstrations: Rosemary Reed
Original art, photography, and drawings: Rosemary Reed
Art direction: Robert Brekke
Senior design: Chuck Donald
Editing: Susan Selix
Demonstration art: Lillian Seto

PUBLISHERS DESIGN GROUP
ROSEVILLE, CALIFORNIA
WWW.PUBLISHERSDESIGN.COM
1.800.587.6666

Printed in China

Contents

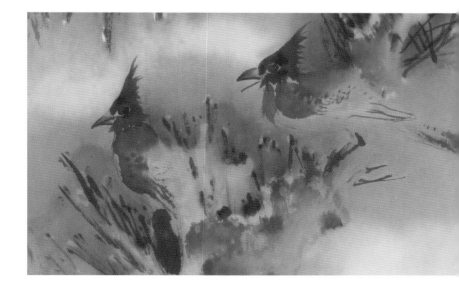

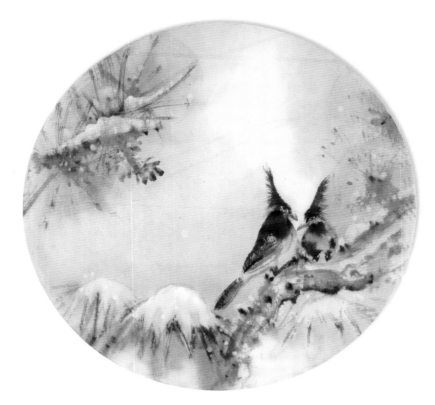

34
CHAPTER IV
Studies of the Pine
Directions for Painting Pine Cones
Directions for Painting Pine Branches
Developing A Style

42
CHAPTER V
Observing & Painting Snow
Discussion on Types of Snow
Techniques for Painting Snow on Branches
Background Washes Define the Snow

50
CHAPTER VI
GALLERY

78
THE ARTIST
Rosemary Reed: Artist & Author 78
(with photo of author skiing)

Some paintings are available as
Fine Art Reproductions
Books and paintings may be ordered by calling
1.866-711-7005, or online at: www.rosemary-art.com

Preface

EVERYONE LOVES California and wants to come
here, especially the region around Lake Tahoe, one of
the most incredible sights on the surface of the earth.
In the wintertime, the white world of the snow as
you journey through the mountains offers an eclectic
experience. It opens new horizons amid the vastness
and reality of the pathways of life, an expansion that
no words can adequately describe.

With my family I have hiked and skied the Sierra
Nevada for many years. During this time I have
enjoyed the spectacular alpine views and appreciated
the complete sense of stillness and solace one expe-
riences in this environment.

Through the medium of watercolors and photog-
raphy, I have shared my knowledge of the snow and
its beauty.

Rosemary Reed

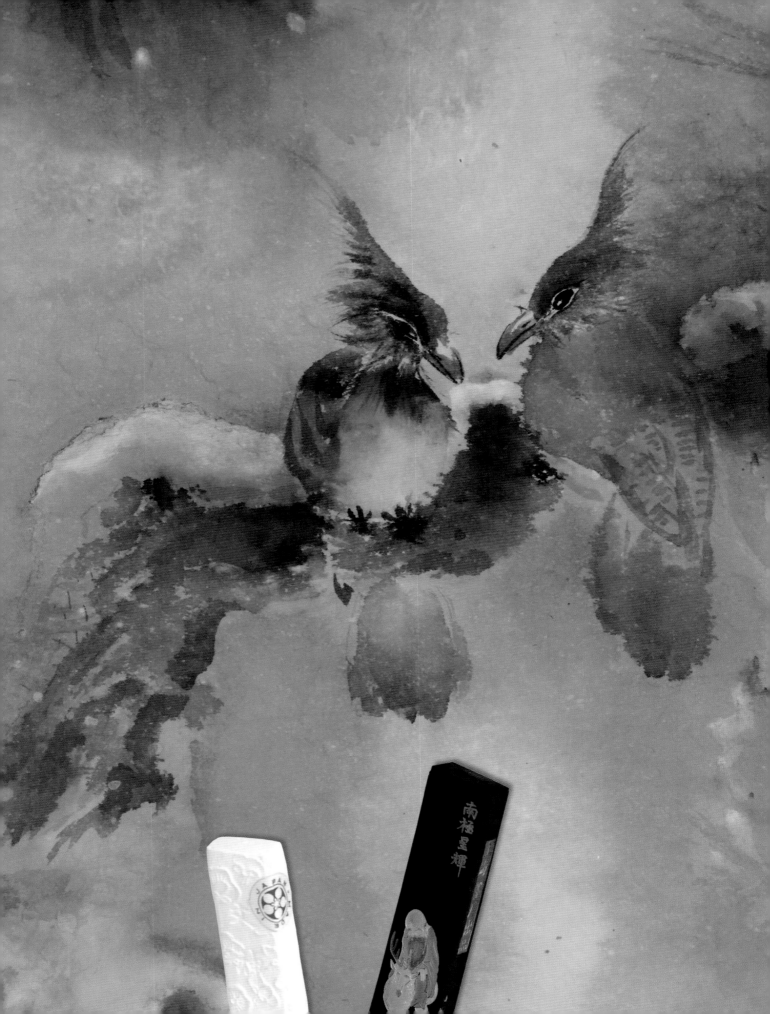

Introduction

THERE IS NO beauty quite like that of the wintertime splendor of the majestic Sierra Nevada Mountains.

Snow Painting is a book designed to help the artist create a style which unites the east and the west, by combining contemporary eastern Oriental brush techniques and materials with western subjects in the region of the beautiful Sierra Nevada Mountains in California.

I painted and photographed in the beautiful Sierra Nevada Mountains about two or three miles west of Echo Summit, an elevation of about 7,700 feet. Lake Tahoe, Pyramid Peak, views from the ranch house at Sierra Ski Ranch, Lover's Leap, Twin Bridges, Pioneer Trail, and Horse Tail Falls are the main points of interest featured in this book.

The studies which have been chosen to be illustrated are the Steller's Jay in Chapter II, the Snowbirds in Chapter III, the Lodgepole Pine in Chapter IV, and snow painting techniques in Chapter V. I have presented a procedure in an Oriental stroke manner that will allow the artist to study and achieve the techniques. I have included photographs to be used as tools to acquaint the artist with the subject and thereby aid her in designing or composing her own paintings. The objective of the artist is to express her own style, with the resultant perfecting of her own way. The main human qualities needed for creative maturity are health, perseverance, insights or perceptions, guided with infinite wisdom.

This book contributes direct communication with words, illustrations, and photos to achieve the perfect performance of the artist. It is designed to support and maintain a behavior or habit system that provides strength and incentive for effective progress. Progress is achieved producing precise and efficient decisions.

Through prayer, divine inspiration leads to greater achievement, higher ideals, clearing of intellectual powers, and a honing of the discipline. This leads the artist to make the right decisions, which aids in achieving plans and goals.

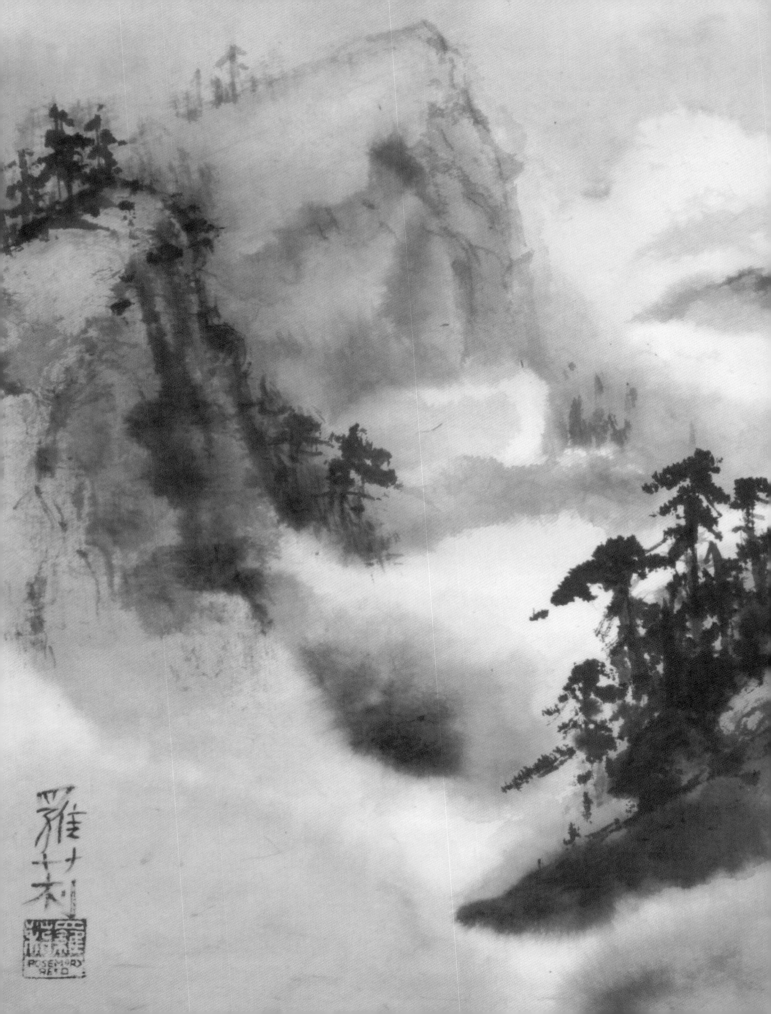

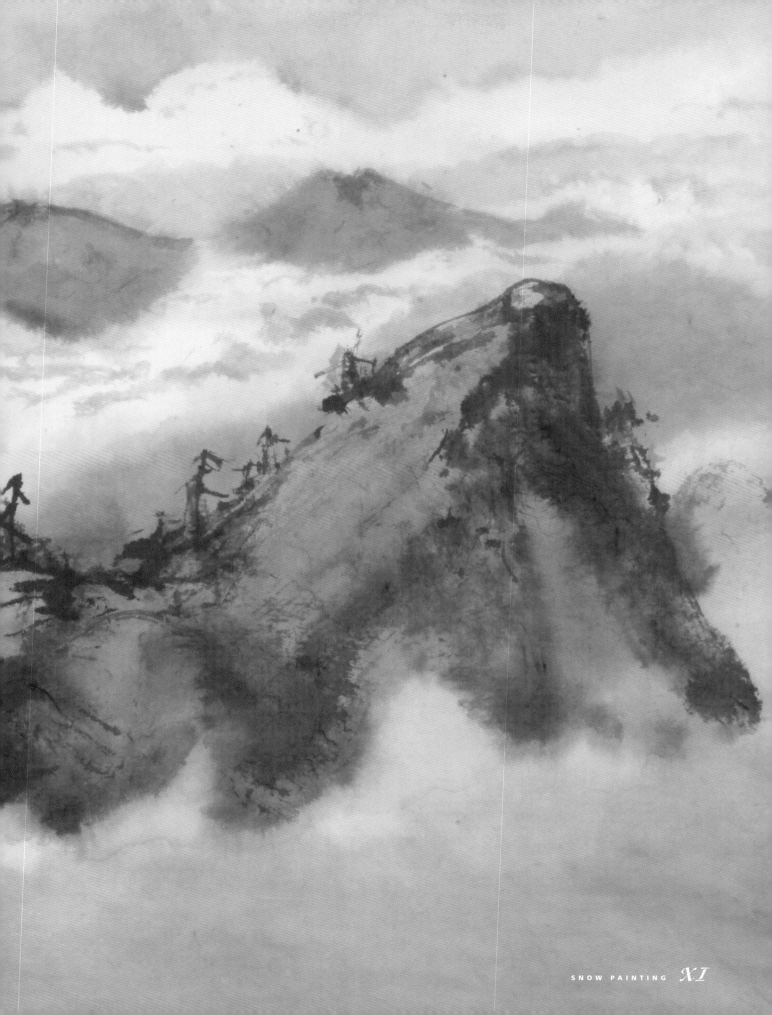

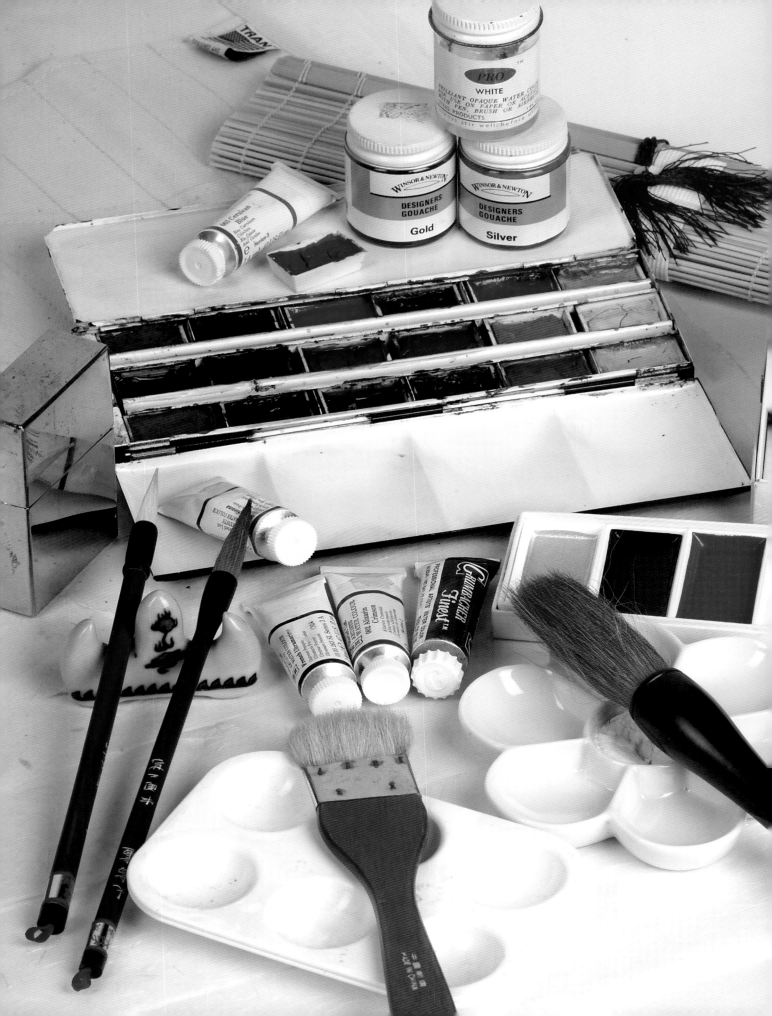

Materials

YOUR TOOLS are intimate partners in expressing and creating your vision. I have learned from verteran artists to collect my favorite tools and papers and know every nuance of how they respond to different strokes. This section discusses the wide variety of materials at your disposal. Many of the Chinese supplies are not readily available outside of major metropolitan areas. However, with access to the internet and mail-order catalogs, you will be able to obtain everything traditional Chinese painters use.

Though it is not necessary to purchase the top-of-the-line brushes and paints, it will serve your apprenticeship well to start with the best. My brushes have lasted for decades and my paints and inks are always reliably consistent from painting to painting. There is no substitute for becoming thoroughly acquainted with your favorite paper and ink. Your work will appear stronger as you gain confidence—not only in your skills, but in your tools, as well.

On the following pages I have included enough to get you started so you will be able to complete paintings, just like those in the gallery section and in the demonstrations. However, there is a world of supplies, accessories, and more comprehensive information on supplies available beyond what is discussed in this book. I recommend that you research and read everything you can about how to use your friends and partners—your tools.

Ink & Ink Stones

INK STONES ARE available in many sizes and shapes. The shapes are usually circular, oval, or rectangular. They usually have a shallow end and deepen to a sloping well as a holder for the ink. The ink stones are made of various materials. Inks are made of stone or sometimes wood. The ink stone should be washed in clean water after each use. Do not leave residue or, when you grind fresh ink, it will be gritty.

It is common practice to buy a collection of beautifull, ornate ink stones to accent the workplace. These are not actually for grinding, but for esthetic pleasure.

Ink (sumi), is available in Japanese (waboku) or Chinese (toboku). The toboku is more opaque and allows a thicker appearance in paintings. The Japanese inks are made in blue and brown varieties. For my winter snow scenes though, I use the blacker Chinese ink. The blacker ink is more reflective and calligraphic than the blue, however, the blue seems to be more subtle in lighter washes on the paper. You will need to experiment with how inks react to different papers.

Be careful when storing your ink stones—they are prone to mildew in humid conditions.

Pre-made liquid ink is available and is used primarily by calligraphers for a denser, or blacker, effect. Though I don't use these inks, or the "pen/brushes" shown here, they can be helpful for spontaneous, gestural practice sessions where one would not have the time to grind the ink..

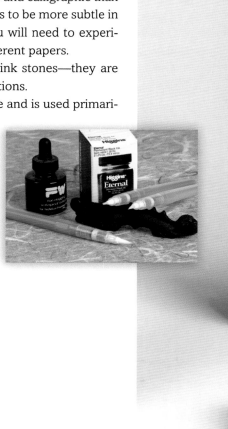

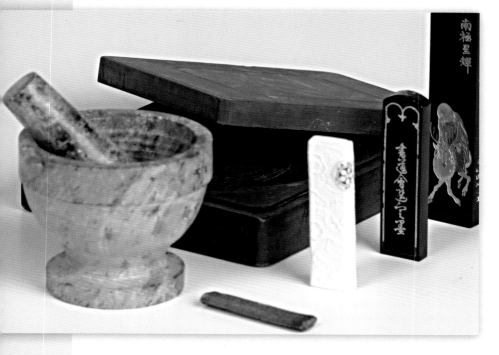

INK GRINDING STONES

Grinding your ink on an ink stone is a ritualistic part of painting. It has been practiced for thousands of years. The best ink stones are beautifully sculpted tools you will treasure for life. But, not all ink stones are alike. Look for the best brand of workmanship—and one that is not too coarse. As you advance in Chinese brush painting, you will want to purchase one made of aged rock. Aged rock ink stones have the best grit for producing the most impressive quality of ink.

INK & GRINDING

GRINDING THE INK There are many different qualities of ink grinding stones and colors of ink sticks available today. It has been my experience that the degree of blackness may vary in many ink sticks.

PROCEDURE

1. Place several brush-loads of water on the flat surface of the grinding stone. Grind enough ink to be able to complete your entire painting.

2. Rub the ink stick in a circular motion on the moistened area. Dip your brush in the ink to test. Be sure your ink is black enough. When painting with your ink, dilute with clean water to obtain the desired shade. I mix my various shades before starting to paint.

3. After grinding your ink, dry your ink stick and store it in its original box.

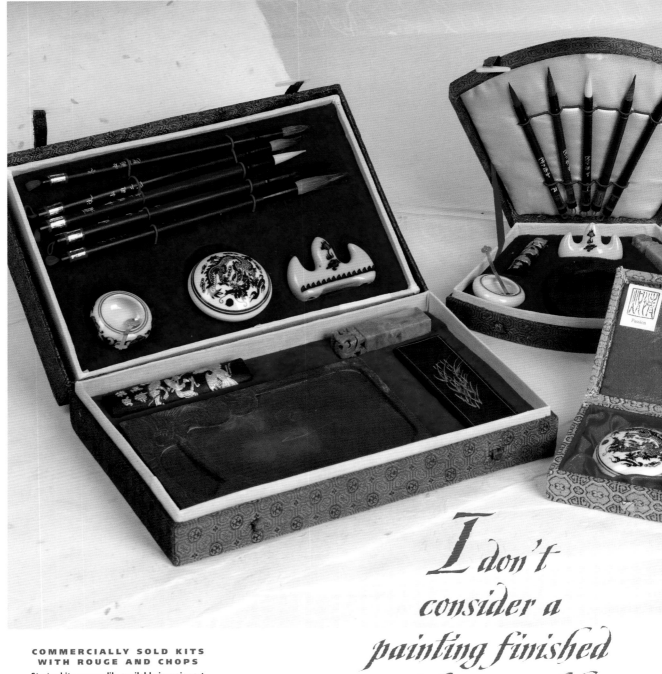

**COMMERCIALLY SOLD KITS
WITH ROUGE AND CHOPS**

Starter kits are readily available in major art
stores. Some kits come with pre-carved com-
mon symbols and brushes, ink, and stones.

*I don't
consider a
painting finished
until my seal has
been applied.*

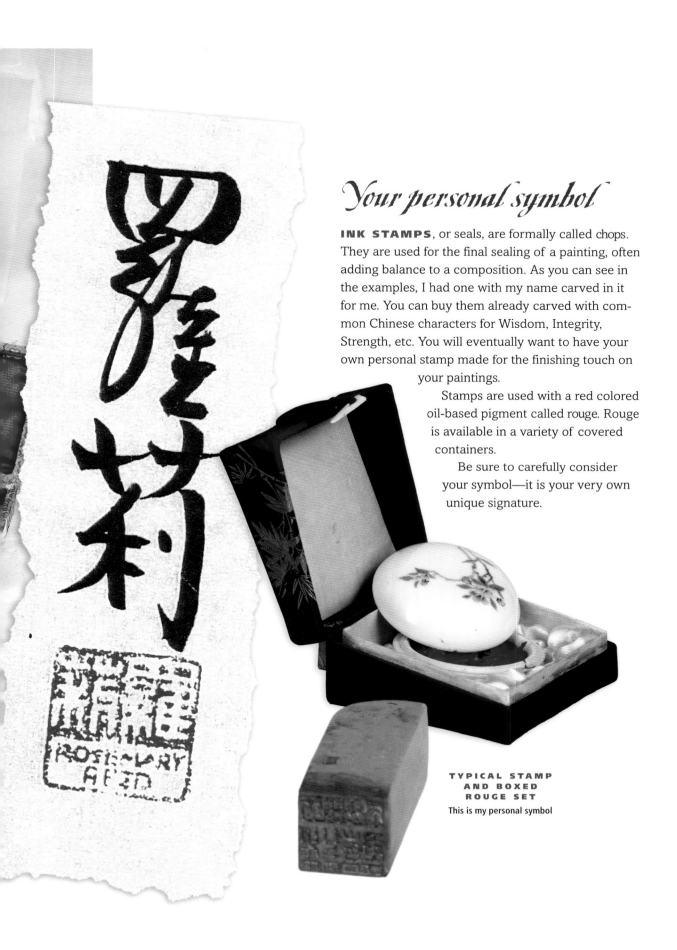

Your personal symbol

INK STAMPS, or seals, are formally called chops. They are used for the final sealing of a painting, often adding balance to a composition. As you can see in the examples, I had one with my name carved in it for me. You can buy them already carved with common Chinese characters for Wisdom, Integrity, Strength, etc. You will eventually want to have your own personal stamp made for the finishing touch on your paintings.

Stamps are used with a red colored oil-based pigment called rouge. Rouge is available in a variety of covered containers.

Be sure to carefully consider your symbol—it is your very own unique signature.

TYPICAL STAMP AND BOXED ROUGE SET
This is my personal symbol

Your workspace

ORGANIZATION of the workspace is one of the most important elements. As you learn to use the tools and techniques in your paintings, you will find that knowing where each tool is kept makes the whole experience seem effortless. I even line up my colors and brushes in a certain order. Any time I want to put my hands on something, I always know exactly where it is.

1. Place a wool blanket or heavy cloth over your table or desk. (The blanket layer under the painting helps absorption and brush feel.) **2.** Place a newsprint over your blanket or wool piece. **3.** Place your rice paper over your newsprint, smooth side up. **4.** Paper weights are used to hold the paper in place. **5.** The artist stands while painting in order to get an overall view of the entire paper. The standing position allows uninhibited movement of the arms and encourages spontaneous brushwork.

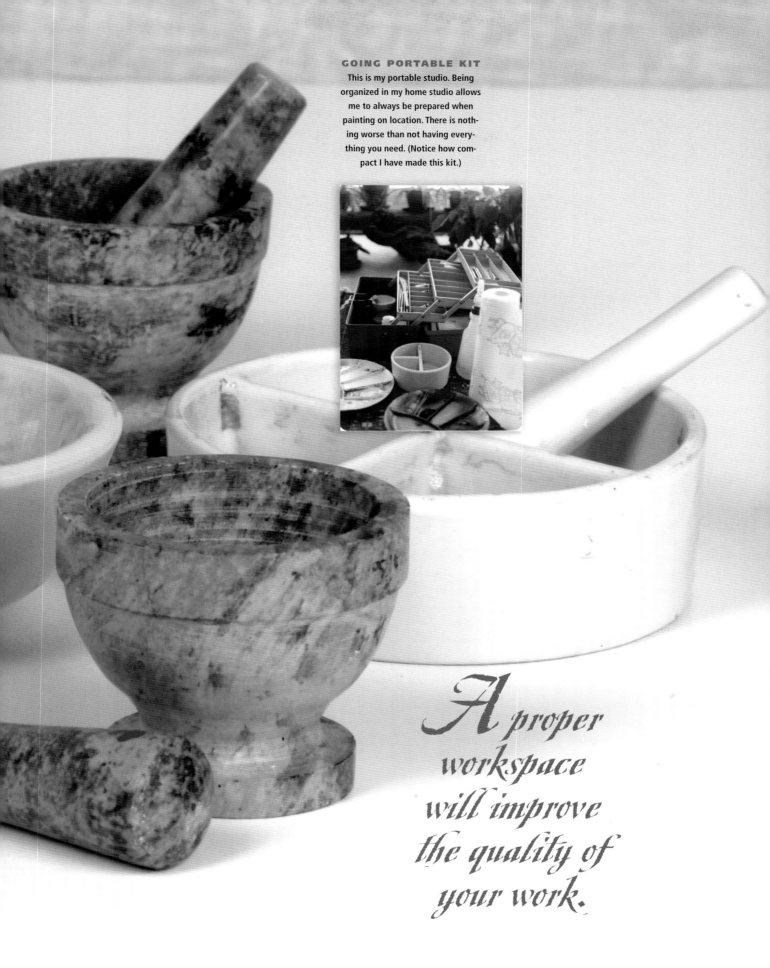

This is my portable studio. Being organized in my home studio allows me to always be prepared when painting on location. There is nothing worse than not having everything you need. (Notice how compact I have made this kit.)

A proper workspace will improve the quality of your work.

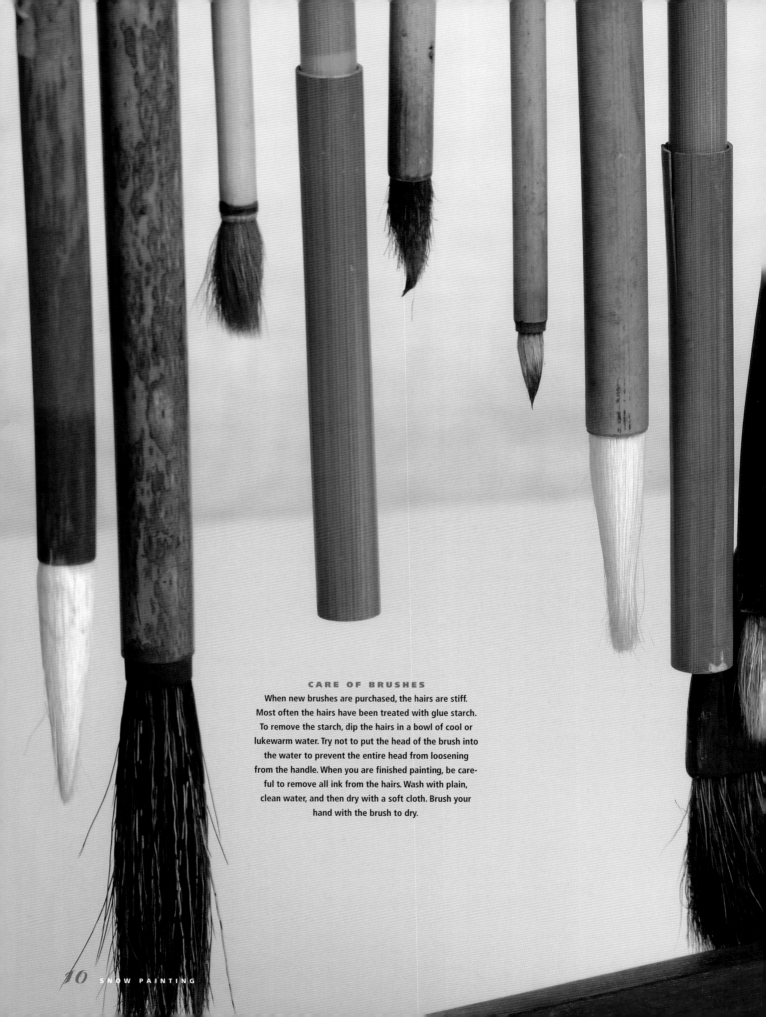

CARE OF BRUSHES

When new brushes are purchased, the hairs are stiff. Most often the hairs have been treated with glue starch. To remove the starch, dip the hairs in a bowl of cool or lukewarm water. Try not to put the head of the brush into the water to prevent the entire head from loosening from the handle. When you are finished painting, be careful to remove all ink from the hairs. Wash with plain, clean water, and then dry with a soft cloth. Brush your hand with the brush to dry.

Your Brushes

FOR MOST OF MY BRUSHWORK with ink and watercolors, I use Oriental brushes which are made of different kinds of animal tufts, with hollow bamboo handles. Some of the tufts are made of horse hair, sheep hair (lambswool), deer hair, goat hair, etc. The brushes range from broad, flat brushes to the round, fine pointed brushes.

THE BRUSHES I most frequently use are described below and pictured on the left.

- Fine round brush: fine line with short hair and stiff—used for detail work.
- Medium round brush: soft sheep hair—excellent for shading.
- Medium round brush: horse hair—rather an all-purpose brush, stiff, has excellent resilience.
- Small round brush: fine line with longer sheep hair for flexibility.
- Medium brush: larger horse hair brush.
- Wide flat brush: This is a very versatile brush made with soft sheep hair. It is excellent for wetting the paper preparatory to painting. It is used for shading by soaking one end of the bush in color and the other end in water.

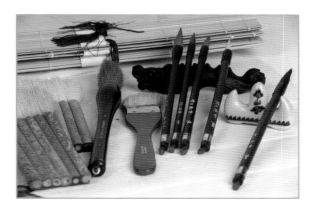

TYPICAL BRUSHES AVAILABLE FROM ART SUPPLY RETAILERS

Paper

AS PICTURED, THERE ARE various kinds of rice papers on the market today. For practicing and experimenting, it is best to start with a less expensive tablet or roll. As you progress with your painting, you will learn that papers come in various weights and degrees of absorbency. Some papers are sized with starch, glue, or gelatin. The side of the paper which has been sized is the smooth side, the other side is rough. Sometimes it is very difficult to tell the difference. Soon you will have favorite papers that you will select for certain subjects. There is a packet of paper on the market with assorted papers in it; the sheets are of a very desirable size.

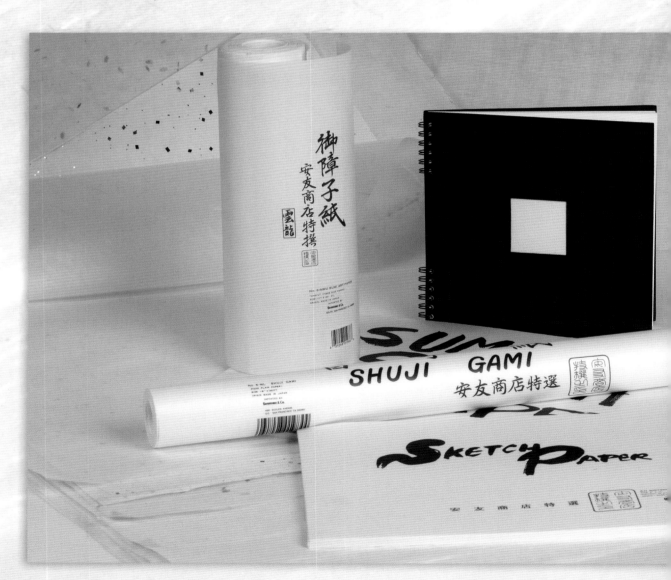

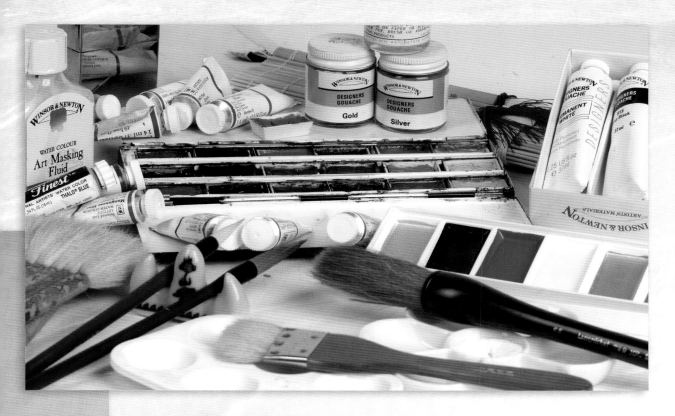

PAINTS

COLORS, similar to watercolors, come in tubes and cakes. Purists use only the best Chinese painting colors. Some of the most popular colors available are: blue, burnt sienna, carmine, cinnabar, gamboge, green, indigo, vermillion, and white, as well as some metallic colors. Chinese colors are more opaque than the traditional Western watercolors. Though some painters blend the use of transparent water-colors with Chinese paints, the demonstrations in this book use primarily the Chinese pigments.

The assortment pictured above shows traditional Chinese paints, and transparent and opaque Western watercolors. The masking fluid is great for preserving small areas that are to remain white and it can be rubbed off after the painting dries. Often though, it is easier to apply opaque Chinese White paint.

When purchasing colors, keep in mind how your paper will be mounted, or stretched. If you need a waterproof color applied to the paper, you should buy color sticks that are labeled as "color ink" to ensure they are not going to run when handled in the stretching process.

Basic Brush Techniques

LOADING YOUR BRUSH Water and ink are used to "charge" the brush. Charging the brush with varying amounts of each is one way to achieve different strokes and effects. These effects will also vary depending on the "ground" (paper) the stroke is applied to and the pressure exerted on the brush. There are two basic ways to control the density of the water/ink mixture. My way is to pre-mix five to six shades of ink in pallet wells or several small cups/bowls beforehand. Another popular way is to load the brush with either ink or water first, and then load with the other (ink or water) to achieve the desired density. Either method allows you to load the brush with several densities of ink for a stroke.

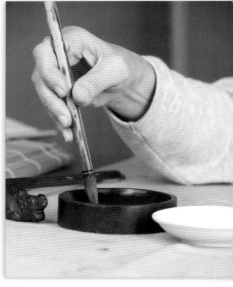

USING DIFFERENT PAPERS

The same brush stroke, with the same amount of water/ink density, will respond differently to each type of paper. The examples on the right show how you can achieve variation by merely using different papers.

Medium-sized paper

Lightly-sized rough paper

Highly-sized smooth paper

INK FIRST

When loading the brush with the ink-first method, you w obtain a lighter, more fluid stroke. As you apply the strok at an angle, you will get a varied stroke that may look li a dry-brush effect, depending on the roughness of the paper. (See examples on far right.)

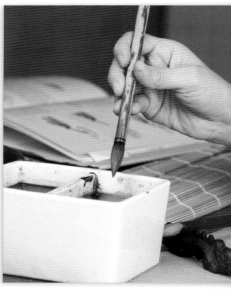

WATER FIRST

When loading the brush for the water-first method, you will obtain a darker stroke, with less dry-brush effect tha the ink-first method. There appears to be a smoother blending of the water and ink. (See examples on far right

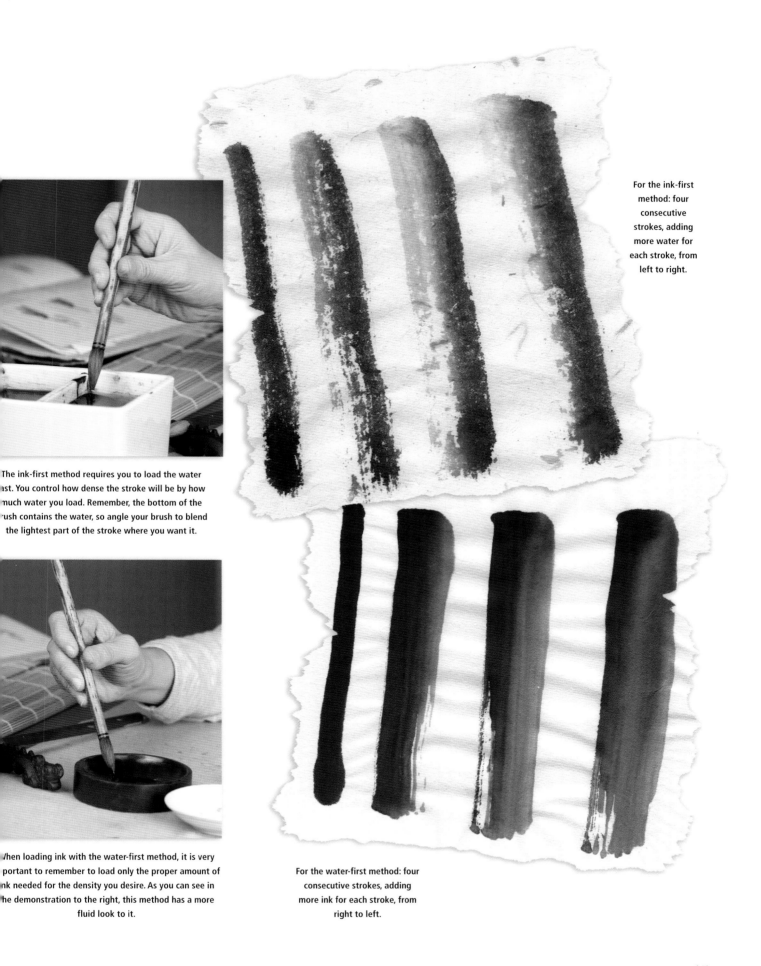

For the ink-first method: four consecutive strokes, adding more water for each stroke, from left to right.

The ink-first method requires you to load the water last. You control how dense the stroke will be by how much water you load. Remember, the bottom of the brush contains the water, so angle your brush to blend the lightest part of the stroke where you want it.

When loading ink with the water-first method, it is very important to remember to load only the proper amount of ink needed for the density you desire. As you can see in the demonstration to the right, this method has a more fluid look to it.

For the water-first method: four consecutive strokes, adding more ink for each stroke, from right to left.

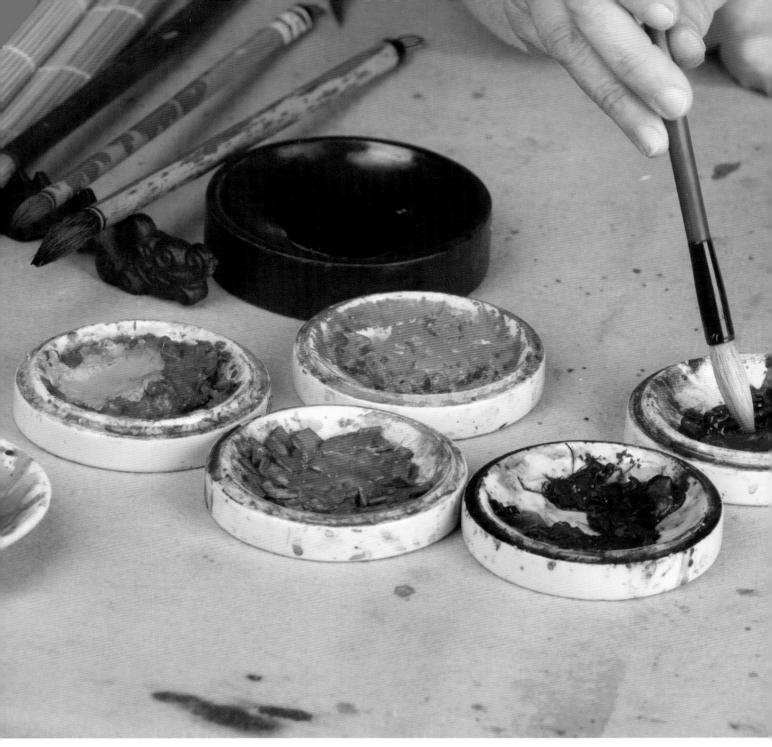

COLOR BLENDING

As you can see on the left, colors can be blended with other colors to get a blended stroke, or used alone. The yellow stroke shows the results of loading the brush with yellow and with water (pigment first). After the first stroke of yellow, the yellow color was not washed out of the brush, but the brush was dipped into green paint for the second stroke. Then, for the third stroke, the brush was again dipped into green for the most intense green yellow-green stroke. For each stroke, the color was not washed out of the brush.

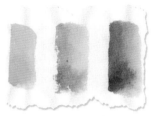

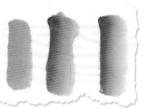

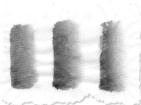

These demonstrations are for the purpose of showing mixing techniques. In actual painting, you would probably want to be cautious of too much intensity.

Colorful strokes

CHINESE PAINTS are the best to use; however, many artists combine them with watercolors. In the demonstrations, I have used primarily traditional Chinese paints. Any color can be used alone, or with another color for a gradated blend, or with ink for a gradation of color and ink. The same basic water-first and ink-first techniques, as explained on the previous pages, apply with color. Water dilutes, diffuses, and blends color. Pigment and ink produce density and intensity. Once again, paper texture and sizing play a big role in the final effect.

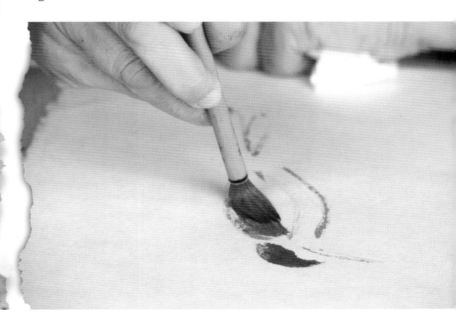

LOADING COLOR AND BLACK

The photo to the left shows how paint color is loaded, then ink. The photo above right shows how this combination works on paper. Sometimes you will need to load ink first and color second. The amount of water needed depends upon how intense, or blended, you want the stroke to look. Usually, water will be mixed into the color and/or ink bath before loading.

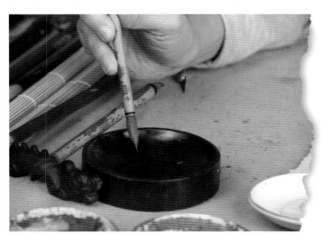

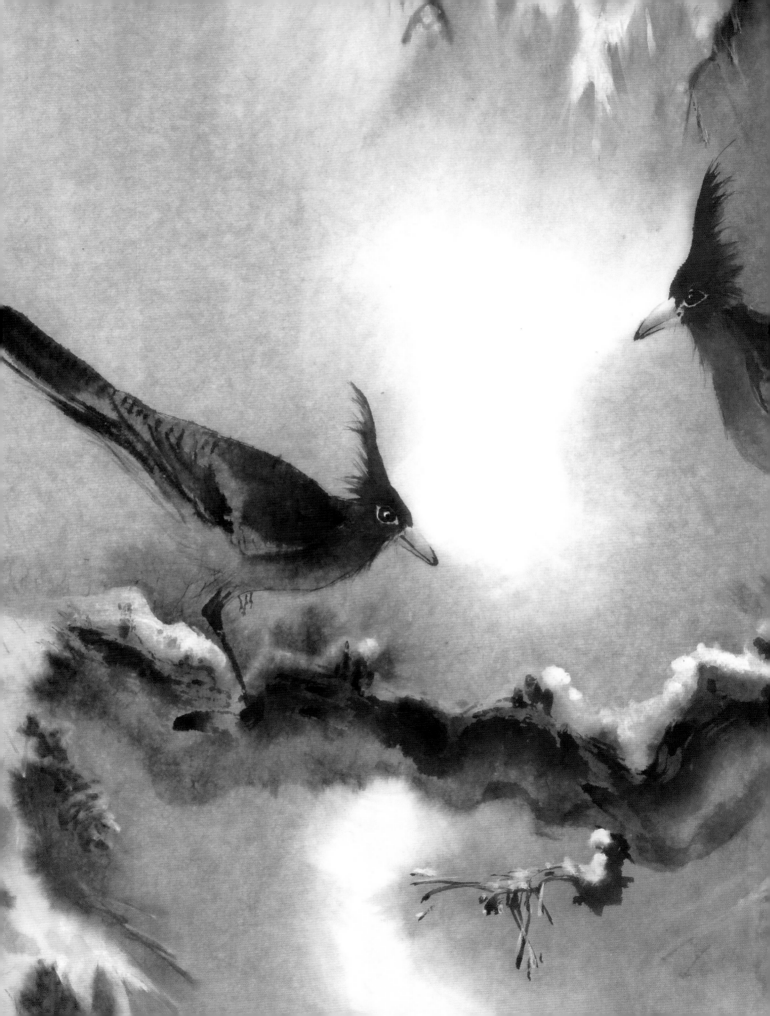

C
H
A
P
T
E
R

2

Steller's Jay

THE STELLER'S JAY is a beautiful bird common-
ly found in Sierra Nevada Mountains region. Its body
is of a rich indigo and cobalt blue. The Chinese color,
stone blue, comes closest to expressing its beauty.
The Steller's Jay has a crest of black feathers with
cerulean blue and indigo stones above each eye, with
small black bars. These run along the back
through the tip of the tail.

The study of birds in their natural envi-
ronment will give the artist insights into
their habits and personalities. These
observations include physical traits,
such as coloring, body shape,
head, wings, feet, etc., as well
as their behavior at various
times, such as mealtime, mat-
ing, and building their nests. It
develops the awareness of the
artist to paint the bird with
freshness and vitality.

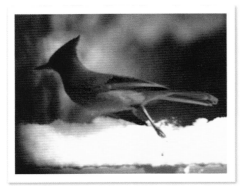

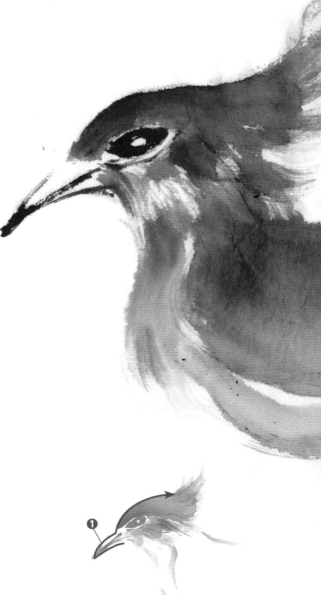

The side view

APPLYING PIGMENT to the paper when painting allows you to use all the techniques previously described. In the case of the side view, there are larger areas that need bigger, wetter, and more blended strokes. Smaller areas and detailed lines will require smaller brushes, sometimes more dense or less dense pigment, with a very controlled amount of water.

It is important to remember not to overwork the strokes. Try to complete an application of pigment in one confident, fresh brush stroke.

You should be able to observe from the sample the type of brush loading (water-first, or pigment-first, or pigment-pigment, or pigment-ink, etc.) is used to achieve certain effects. Notice also the use of wet to dry strokes, or pure dry strokes.

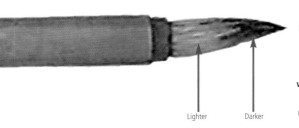

Lighter Darker

BEFORE YOU START
Mix up five shades of ink from lightest to darkest (#1 to #5) in the pallet wells or bowls. This way you'll have diluted ink in the exact shades and they will be ready to mix with the blue color, or use alone.
Sketch the bird by outlining it with light gold.

PAINTING THE HEAD
BEAK Use a small brush loaded with #4 ink with blue, and apply dry-brush technique on paper. (Fig 1)
EYE Dry-brush #1 ink with blue in circle around eye. Use #5 ink for pupil. No ink for highlight.
HEAD CROWN Load horse hair brush with water and then #4 ink with blue color. Start at the beak area and drag brush across head to the crown and feather area, flattening the brush as you go toward the plume. Apply wispy dry-brush strokes for feathers.
BEAK Load a small brush with just enough #4 ink to be able to apply dry brush strokes under the neck, downward and around under the wing to meet the tail.

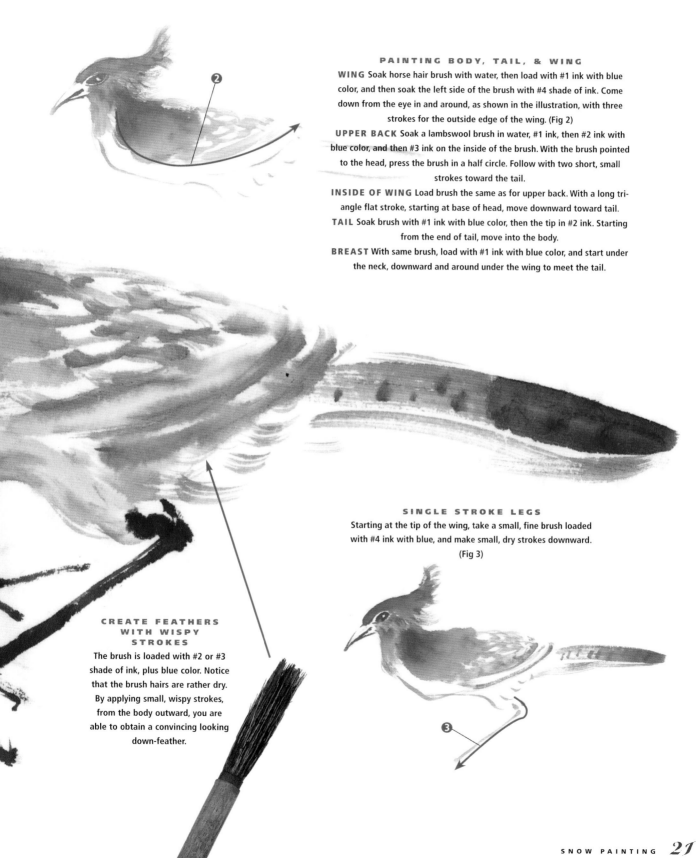

PAINTING BODY, TAIL, & WING

WING Soak horse hair brush with water, then load with #1 ink with blue color, and then soak the left side of the brush with #4 shade of ink. Come down from the eye in and around, as shown in the illustration, with three strokes for the outside edge of the wing. (Fig 2)

UPPER BACK Soak a lambswool brush in water, #1 ink, then #2 ink with blue color, and then #3 ink on the inside of the brush. With the brush pointed to the head, press the brush in a half circle. Follow with two short, small strokes toward the tail.

INSIDE OF WING Load brush the same as for upper back. With a long triangle flat stroke, starting at base of head, move downward toward tail.

TAIL Soak brush with #1 ink with blue color, then the tip in #2 ink. Starting from the end of tail, move into the body.

BREAST With same brush, load with #1 ink with blue color, and start under the neck, downward and around under the wing to meet the tail.

SINGLE STROKE LEGS

Starting at the tip of the wing, take a small, fine brush loaded with #4 ink with blue, and make small, dry strokes downward. (Fig 3)

CREATE FEATHERS WITH WISPY STROKES

The brush is loaded with #2 or #3 shade of ink, plus blue color. Notice that the brush hairs are rather dry. By applying small, wispy strokes, from the body outward, you are able to obtain a convincing looking down-feather.

The front view

THE ADDITION OF WHITE PAINT to the pallet will expand your options. We will be charging the brush with up to three colors at a time for these exercises. Much of the same applies to the head, breast, eyes, crown, and plume, as in the side view demonstration.

When observing the jay from the front, at times you will see a well-seated, rested bird on a branch, or you may notice an alert, upright, tense bird (like the one in the photo below). Try to bear in mind the body language before sketching or applying paint strokes.

BEFORE YOU START

Mix up the five shades of ink. Prepare two or three consistencies of wet colors. We will be using ink shades along with indigo, cerulean blue, and white.

Outline the basic contour with light gold color.

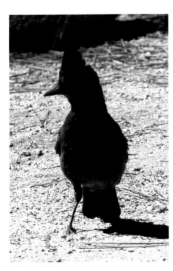

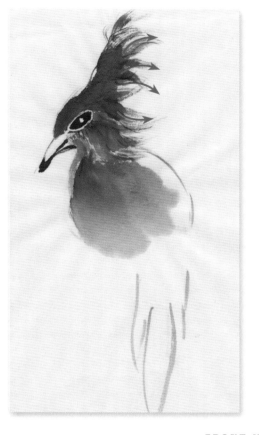

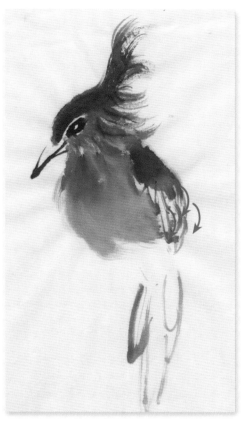

FRONT VIEW PAINTING STEPS

BREAST Load horse hair brush with thin white paint, then cerulean, and the tip with indigo. Starting under the neck, flatten brush downward, so that the tip is under the neck, and drag down.

HEAD With small horsetail brush, load with #4 ink with Indigo color. Start at beak and move upwards toward crown and plume feathers. Place more strokes around top of eye and out.

BEAK & EYES Load small pointed brush with #5 ink. (Leave center of pupil unpainted.)

WING Load horse hair brush with #4 ink and medium blue color. Drag brush downward from neck area until dry-brush effect appears at bottom of stroke. Repeat same to complete full width. Notice the short sporadic strokes at the bottom of wing around the small white, open areas.

TAIL Use medium size lambswool brush, loaded with thin white color, then cerulean blue, and the tip loaded with #3 ink. Drag downward for each tail feather. Go back in while still wet with a drop of #4 ink to place in dark accents on tail feathers. Notice both dry-brushed and hard edges on feathers.

FEET Load a small brush with #5 ink and press the brush flat and drag downward while lifting the brush to complete a thinner stroke at the bottom.

FINISHING Feathers and textures can be added with a medium blue, somewhat dry brush, with outward or downward strokes from the body, head, or tail areas. The branch can be painted with #3 ink loaded on a medium soft brush.

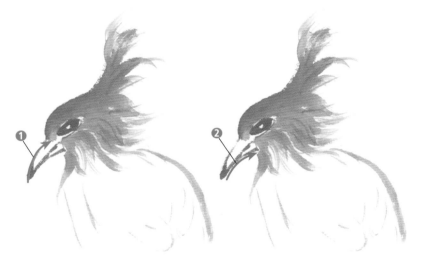

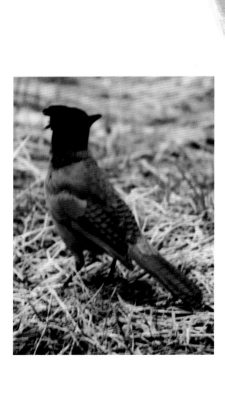

PAINTING THE REAR VIEW

We will start with the head and beak first. Mix up your five shades of ink.
Then prepare your indigo and cerulean blue.

BEAK Load small brush with #4 ink, use dry-brush strokes on dry paper.

EYE Paint circle around eye with #2 ink, dry brush on dry paper. Then paint the
pupil with #4 or #5 ink, leaving white area in middle of pupil.

HEAD Load horse hair brush with indigo color and the tip with #3 ink. Drag
brush from beak area upwards to the right while pressing brush into paper.
Paint crown and move brush upwards to the plume of feathers.

CHEEK BONE Load the brush with #3 ink and cerulean blue. Start under the
eye and brush downward toward the body. Majority of pigment is at the start
of each stroke, allowing feathered look toward the end of stroke.

BODY Load lambswool brush with #1 ink, then the middle of the brush with
#2 ink and indigo, then the tip with #3 and cerulean blue, and then soak the
right side of the brush with #4 ink and indigo. Starting at the base of the neck,
flatten the brush to a triangle shape and drag it down so the stroke is com-
pleted in one pass. Pigment will lighten as you move downward.

WING Load horse hair brush with #3 ink and cerulean. Make one downward
stroke, curving the outline of the wing to end at the tail.

TAIL Soak brush with #1 ink, then dip in #2 ink and indigo for the middle of
brush, then dip the tip in #3 ink and indigo. Make three strokes downward.

DETAILS See directions on right-hand page.

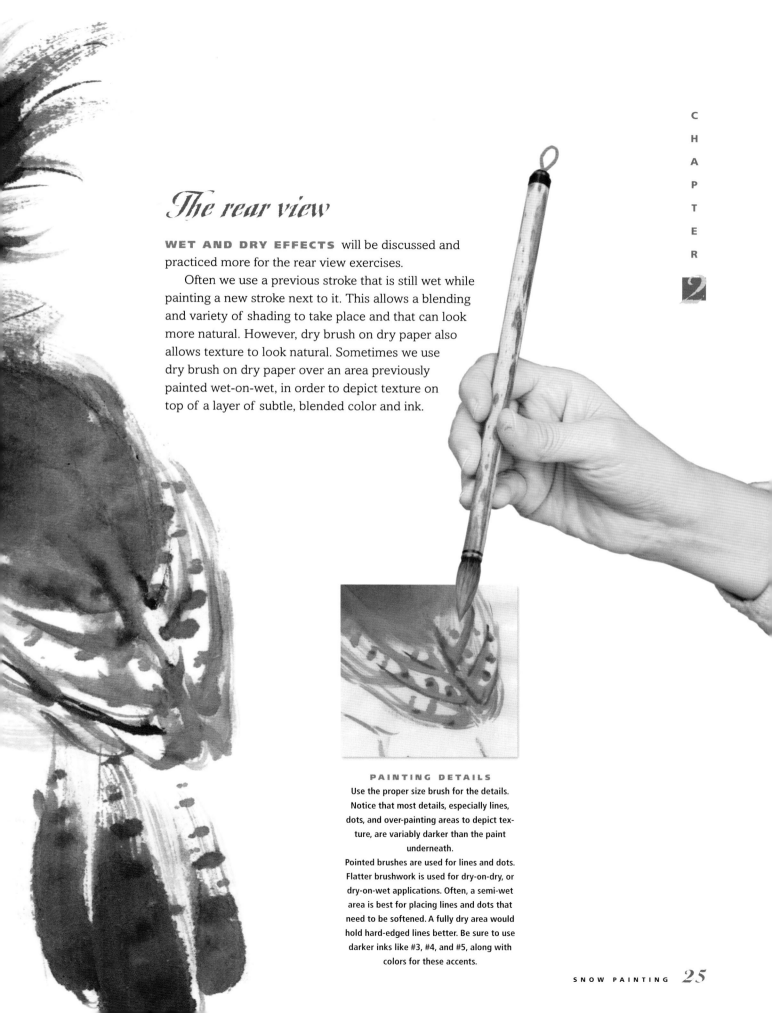

The rear view

WET AND DRY EFFECTS will be discussed and practiced more for the rear view exercises.

Often we use a previous stroke that is still wet while painting a new stroke next to it. This allows a blending and variety of shading to take place and that can look more natural. However, dry brush on dry paper also allows texture to look natural. Sometimes we use dry brush on dry paper over an area previously painted wet-on-wet, in order to depict texture on top of a layer of subtle, blended color and ink.

PAINTING DETAILS

Use the proper size brush for the details. Notice that most details, especially lines, dots, and over-painting areas to depict texture, are variably darker than the paint underneath.

Pointed brushes are used for lines and dots. Flatter brushwork is used for dry-on-dry, or dry-on-wet applications. Often, a semi-wet area is best for placing lines and dots that need to be softened. A fully dry area would hold hard-edged lines better. Be sure to use darker inks like #3, #4, and #5, along with colors for these accents.

Head & beak

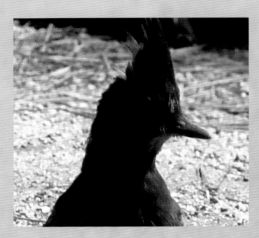

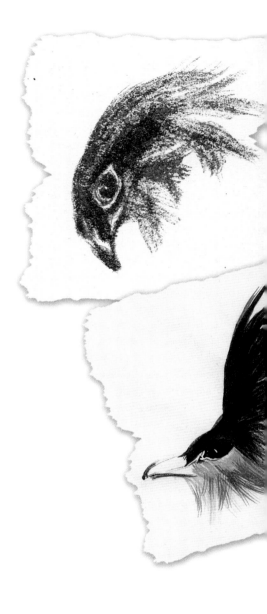

STYLISTIC BRUSHWORK An important element of mastering brush painting is found in small, ink-only, gestural studies. I like practicing on the heads of birds and on branches because they offer the best opportunities to instill expression and character into the line. As you can see, some heads are done with simple, wet brush strokes on moist paper, some are done with only the dry-on-dry technique, and some are a combination.

A WORD ON FOLIAGE The branches always require some strokes of dry-on-dry and dry-on-wet, even if there is no underpainted area. Usually, the brushwork for branches starts with some wet-on-dry and some wet-on-wet strokes, with the dry-on-wet and dry-on-dry strokes layered on top. Limited details are also added, both to wet and dry underpainted strokes.

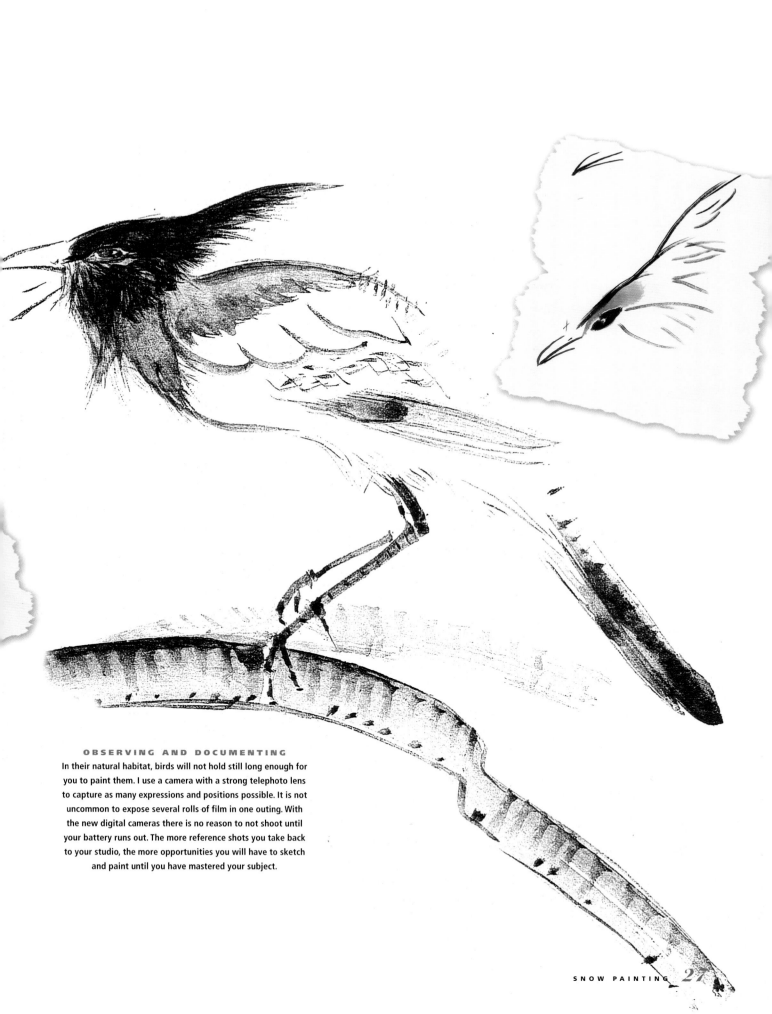

OBSERVING AND DOCUMENTING

In their natural habitat, birds will not hold still long enough for you to paint them. I use a camera with a strong telephoto lens to capture as many expressions and positions possible. It is not uncommon to expose several rolls of film in one outing. With the new digital cameras there is no reason to not shoot until your battery runs out. The more reference shots you take back to your studio, the more opportunities you will have to sketch and paint until you have mastered your subject.

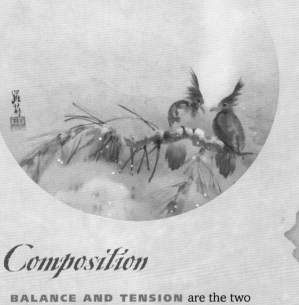

Composition

BALANCE AND TENSION are the two
forces that must be dealt with when compos-
ing your paintings. Tension and movement are
created by introducing angular or strong direc-
tional devices, or by offsetting the composition to
be heavier, lighter/darker, more colorful, or
busier in one area when contrasted to another.
The round painting above shows a busy bottom
section with detail and focus-of-interest (the
birds) placed way to the right, contrasted against
a very restful, soft upper background. Avoid sym-
metry and placing too many details, or
areas/subjects of interest, everywhere. Make
sure that all elements point to the main subject.

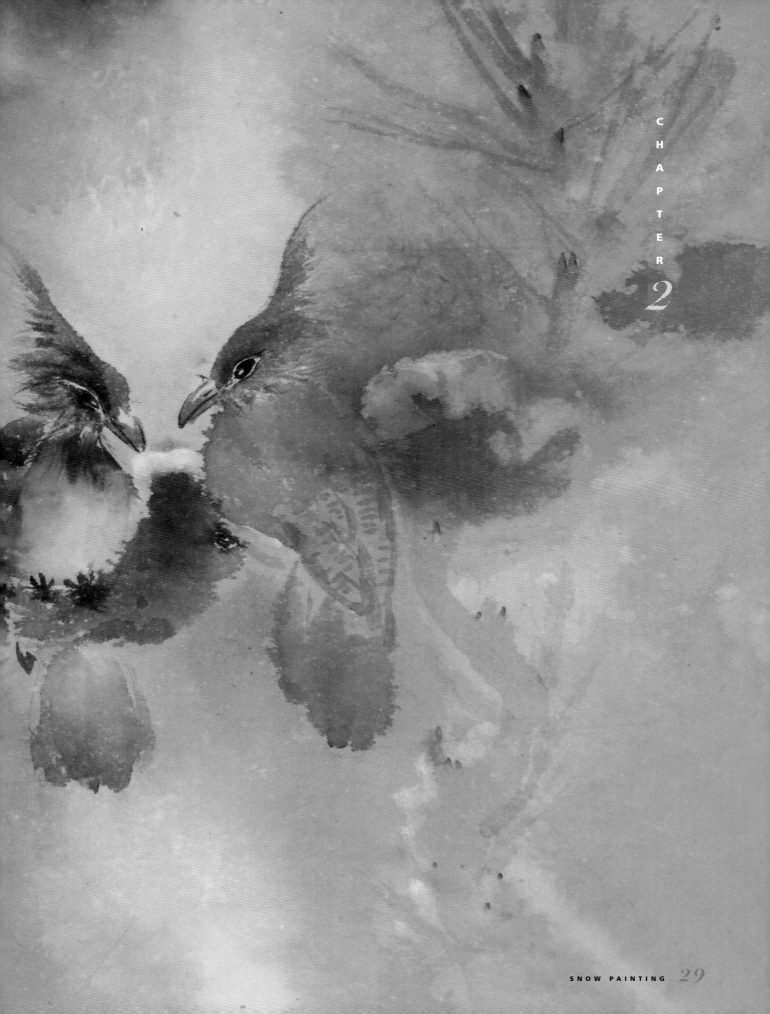

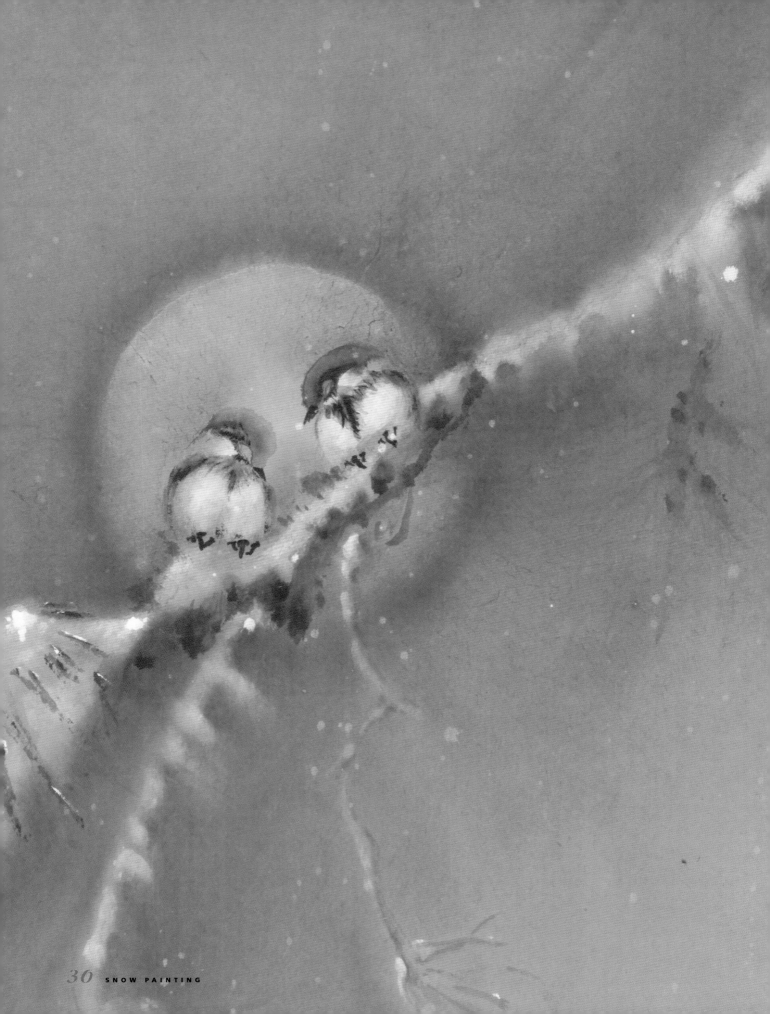

Snowbirds

THESE WINTER LOVERS are breathtaking to see in the beautiful snow-covered forests of the Sierra Nevada.
They are fatter and smaller than the Steller's Jay, and they are a warmer, brown and sienna-colored bird. There is no plume of feathers above the crown of the head.

The Snowbird has a light underbelly and breast, with a light-colored collar around the neck. The contrast between the jays and the Snowbirds is more than just color and body shape. The Snowbirds appear to be more at peace with each other than the jays—they sit closer together and are more quiet, as well.

Once again, it is important to study the birds in their natural environment. The artist needs all the insight available from direct observation into the behavior patterns they exhibit when mating, frightened, cautious, eating, sleeping, or just relating to each other. As I stated about the jays, the artist becomes more aware when painting from personal experience by studying the birds in their natural environment.

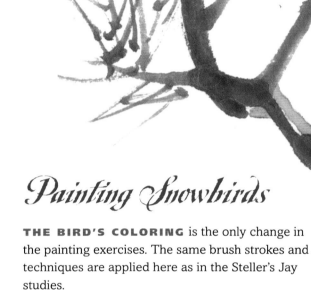

Painting Snowbirds

THE BIRD'S COLORING is the only change in the painting exercises. The same brush strokes and techniques are applied here as in the Steller's Jay studies.

In order to achieve the warm pallet, I will use a new color called vandyke brown. There is also more wet-on-wet and blending of colors to soften the transitions in this exercise.

Mix up five shades of ink (#1 through #5, lightest to darkest). Also, prepare the brown and white pigments in pallet wells.

PAINTING HEAD AND WING
Soak horse hair brush with ink #2, then load the center of brush with dark brown pigment, and then load #4 ink on the tip. In the example, you can see the downward stroke and how the pressure fills an area. For the wing, just continue without reloading. (If more density is desired, reload the brush.)

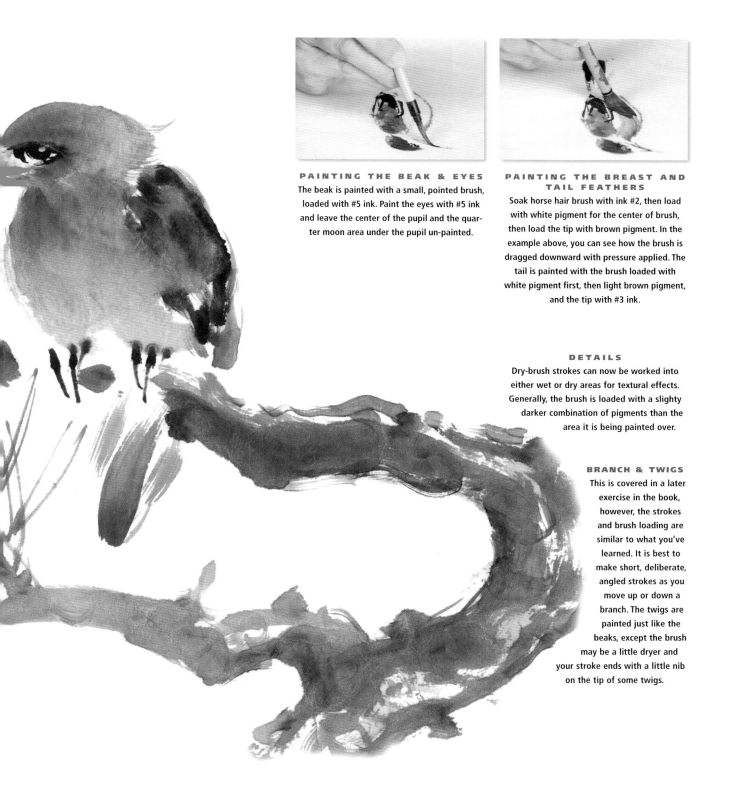

PAINTING THE BEAK & EYES

The beak is painted with a small, pointed brush, loaded with #5 ink. Paint the eyes with #5 ink and leave the center of the pupil and the quarter moon area under the pupil un-painted.

PAINTING THE BREAST AND TAIL FEATHERS

Soak horse hair brush with ink #2, then load with white pigment for the center of brush, then load the tip with brown pigment. In the example above, you can see how the brush is dragged downward with pressure applied. The tail is painted with the brush loaded with white pigment first, then light brown pigment, and the tip with #3 ink.

DETAILS

Dry-brush strokes can now be worked into either wet or dry areas for textural effects. Generally, the brush is loaded with a slighty darker combination of pigments than the area it is being painted over.

BRANCH & TWIGS

This is covered in a later exercise in the book, however, the strokes and brush loading are similar to what you've learned. It is best to make short, deliberate, angled strokes as you move up or down a branch. The twigs are painted just like the beaks, except the brush may be a little dryer and your stroke ends with a little nib on the tip of some twigs.

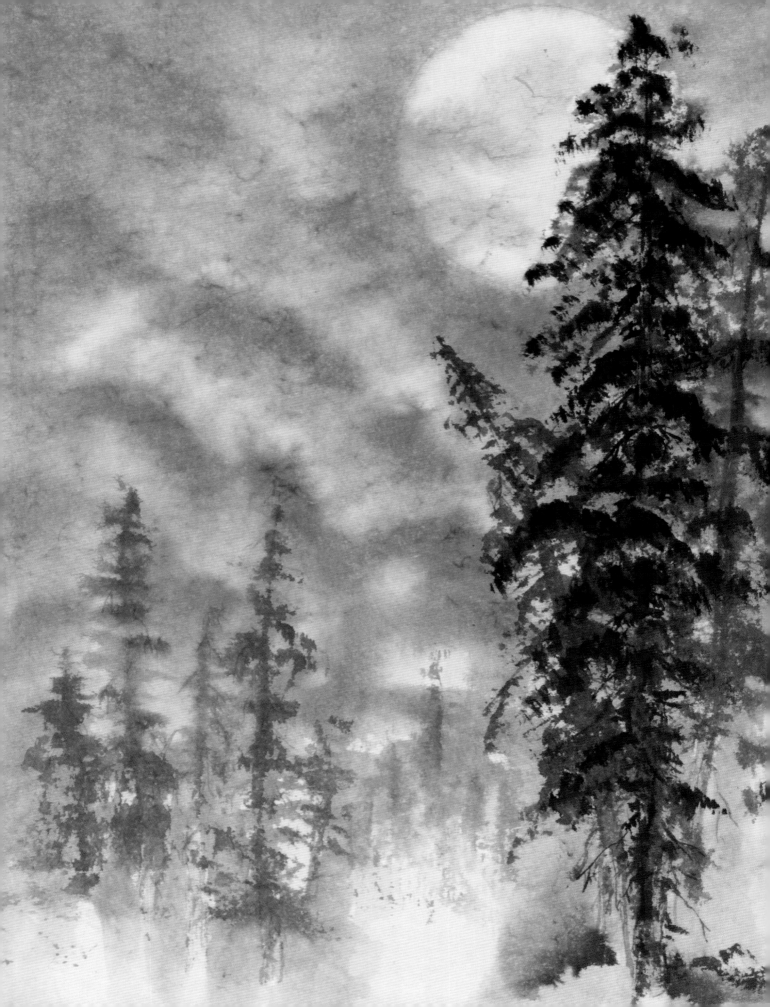

Studies of the pine

THE PLANT IS NOT isolated from its environment. It acquires a more intense vitality when it is immersed in the atmospheric environment which surrounds it.

Nature is used to help the artist to create his painting. It brings to the mind of the artist its aliveness and freshness. Here are illustrations of how the artist can acquaint herself with the details of the subjects she paints, thereby developing her own sense of awareness and observation. The artist develops an ability to draw them on paper in her own style, and in their natural freshness. She creates her own painting.

The demonstrations in this chapter lead you through the basics of painting cones, branches, twigs, and the textural details that add convincing effects. A short discussion about developing your own style finishes the chapter. Tree trunks, branches, and twigs are excellent compositional tools that can lead the viewer's eye to where you want focus.

Painting cones

NATURE OFFERS unlimited opportunities to study its bountiful expression of beauty in line, shape, texture, and color: the twisting and turns, the sudden, abrupt changes in angles, the upward reach of branches offering their fruit graciously. These exercises will help you gain confidence in drawing the basic branch, twig, and cone compositions that will eventually hold snow and birds in your finished paintings.

STUDY THE CONE

The pine cone is actually the fruit of the pine tree. It consists of a collection of overlapping *scales,* spirally arranged around a central stalk, or axis. (These are actually modified, spore-bearing leaves.) Notice that cones cluster in twos and threes at the end of the upward-reaching branches. They are high and low on the tree. Also, notice that there is a pattern to the scales, and that they can be tightly closed, partially open, or completely opened up. The ends of the scales have sharp points and should be handled with care.

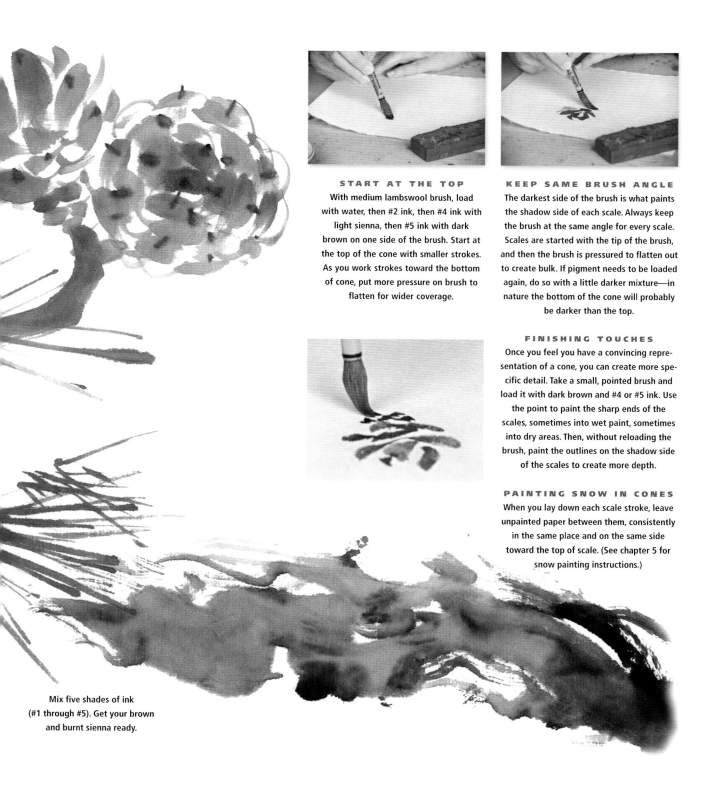

START AT THE TOP

With medium lambswool brush, load with water, then #2 ink, then #4 ink with light sienna, then #5 ink with dark brown on one side of the brush. Start at the top of the cone with smaller strokes. As you work strokes toward the bottom of cone, put more pressure on brush to flatten for wider coverage.

KEEP SAME BRUSH ANGLE

The darkest side of the brush is what paints the shadow side of each scale. Always keep the brush at the same angle for every scale. Scales are started with the tip of the brush, and then the brush is pressured to flatten out to create bulk. If pigment needs to be loaded again, do so with a little darker mixture—in nature the bottom of the cone will probably be darker than the top.

FINISHING TOUCHES

Once you feel you have a convincing representation of a cone, you can create more specific detail. Take a small, pointed brush and load it with dark brown and #4 or #5 ink. Use the point to paint the sharp ends of the scales, sometimes into wet paint, sometimes into dry areas. Then, without reloading the brush, paint the outlines on the shadow side of the scales to create more depth.

PAINTING SNOW IN CONES

When you lay down each scale stroke, leave unpainted paper between them, consistently in the same place and on the same side toward the top of scale. (See chapter 5 for snow painting instructions.)

Mix five shades of ink (#1 through #5). Get your brown and burnt sienna ready.

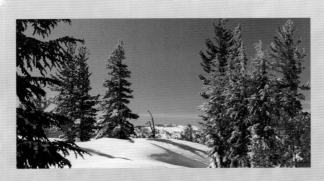

Painting branches

ONCE AGAIN, let me express the invaluable experience you get from observing your subject first-hand. In approaching the painting of branches and twigs, study the direction of the needles, the texture of the branches, the junctions of stems, and how the light shapes the objects. The tree boughs in the above picture are somewhat laden with snow, however, the branches we will paint for these exercises will be free of excess weight. (The next lesson shows how to paint snow on branches.)

BASIC TECHNIQUES FOR BRANCHES

Mix five shades of ink (#1 through #5). Also prepare vandyke brown, light sepia, and medium sepia pigments.

FIRST BRANCH Soak lambswool brush with water, dip wet brush into medium sepia, then load the tip with brown. Start the brush stroke just under the pine cone you completed in the last lesson. Move the brush downward, away from the cone. Within a few inches start to angle the stroke downward. Then angle it in another direction. Notice the slight variations from straight to curved. Keep the brush tip pointed in a consistent direction to show light coming from one source. Also, try lifting the brush at each angle change and loading it again—creating a noticeable joint when you place the brush down on the paper again to start the next stroke.

MORE BRANCHES Continue to load and stroke. Try not to be too consistent in stroke applications—size, curvature, length, density, moisture, etc.

BRANCH MODELING Create more shadow in places by loading a horse hair brush with medium sepia, then with #4 ink and brown. Apply pigment to the underside of branches with broken and dry-brush lines. Allow some areas to blend into the previous strokes where they are still moist.

NEEDLES Load a medium small, pointed, horse hair brush with dark sepia and #3 ink, then load tip with brown and #5 ink. Apply stroke outward from the source. Paint several strokes before reloading brush, thus allowing the pigment to vary as the brush empties.

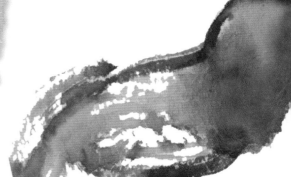

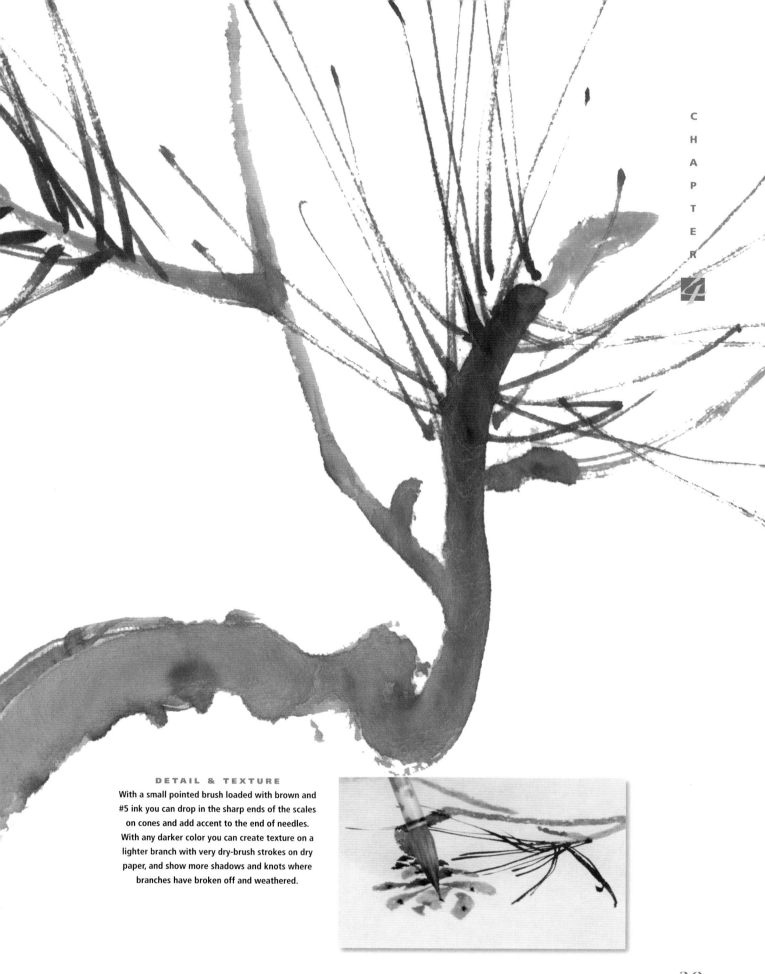

DETAIL & TEXTURE

With a small pointed brush loaded with brown and #5 ink you can drop in the sharp ends of the scales on cones and add accent to the end of needles. With any darker color you can create texture on a lighter branch with very dry-brush strokes on dry paper, and show more shadows and knots where branches have broken off and weathered.

Developing a style

STYLISTIC APPROACH is one aspect of your paintings that will begin to be recognized. After you have mastered the techniques and tools, and have painted many scenes, your own style will emerge. My style tends to be soft, luminous backgrounds, with trees, branches, and snow developed more deliberately near the subject of focus.

My pallet tends to be very limited, with the most intense application of color around the area of focus. The artist even develops a compositional theme in her paintings. Mine is the use of strong, angular, directional devices (like limbs, twigs, color against color, and the posture of the subject) that work well to create an overall style that other people start to notice as my stylistic approach.

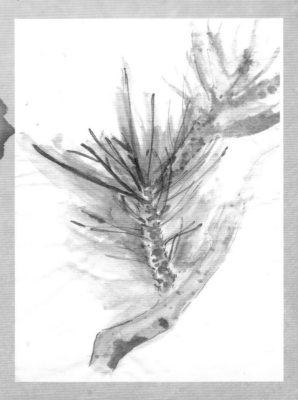

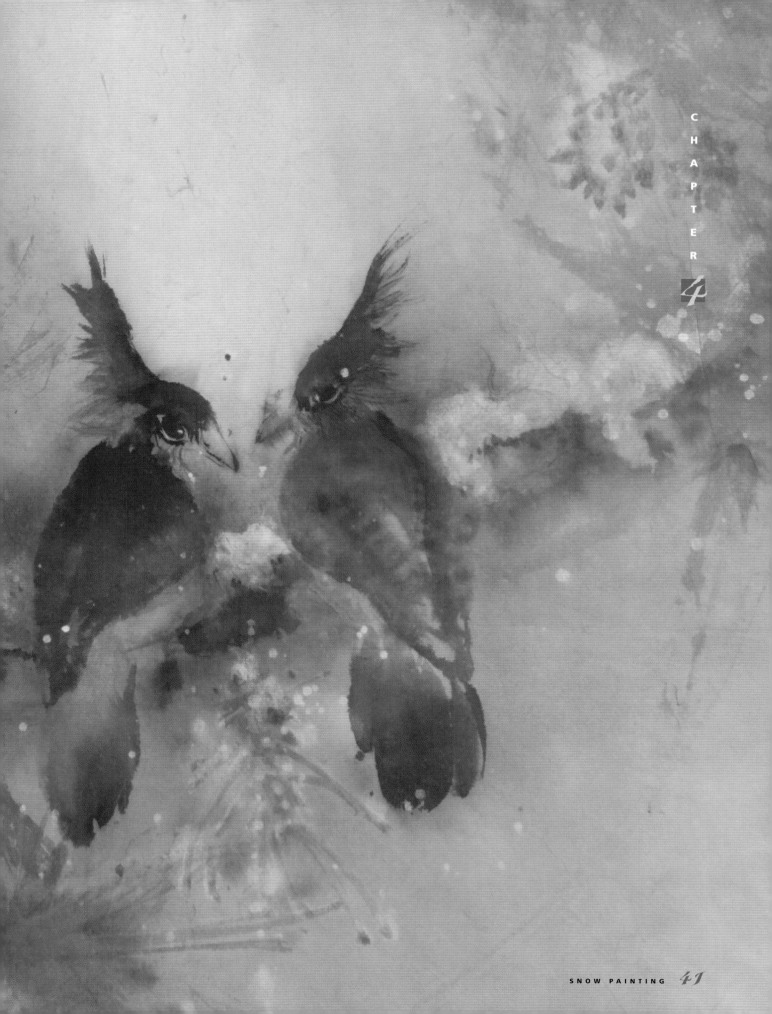

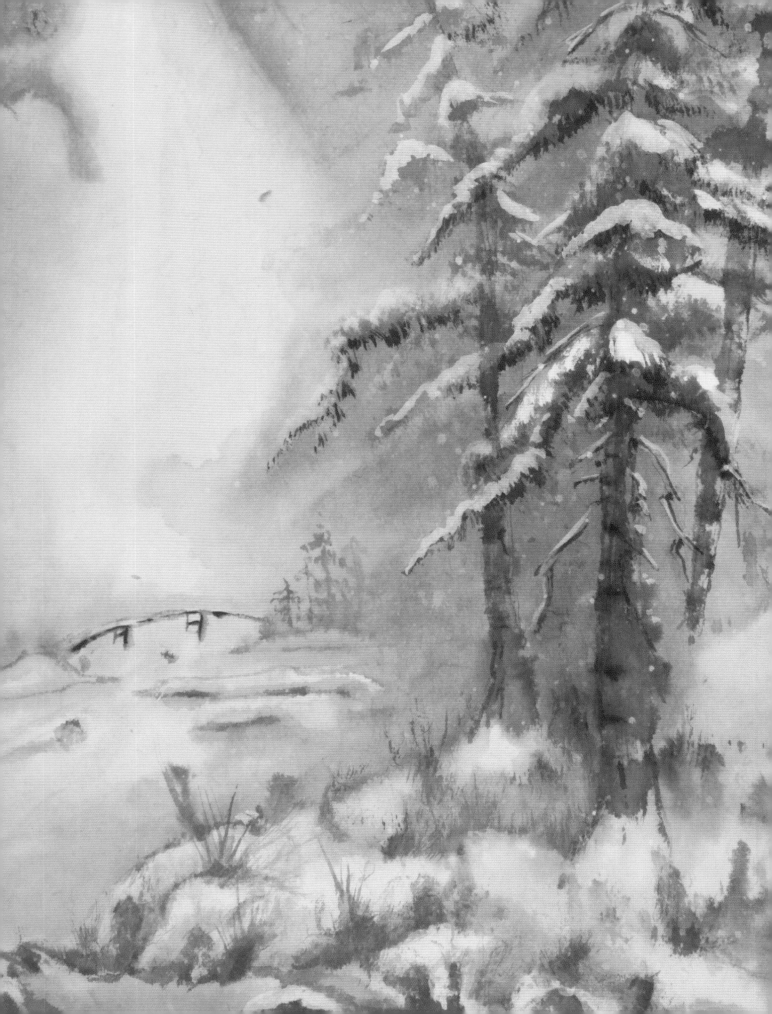

Observing Snow

PAINTING SNOW requires an understanding of the way it affects the objects that will be included in your painting. There is no substitute for actually spending lots of time in snow-covered landscapes. I spent many winters at my cabin in the mountains above Lake Tahoe, California. As a student of art and nature, it was not long before I realized that snow changes. During a storm snow will look, feel, and act a certain way depending on the moisture content and velocity of the storm. After the storm, the branches and snow on the ground reveal many things. A fresh, cold powder snow is very different from a two-day-old moist snow. The next pages contain pictures that display what I'm talking about. (The photo at right shows how a recent snowfall of medium moisture content, that has had a little time to melt, looks, and how it affects the tree's branches and twigs.)

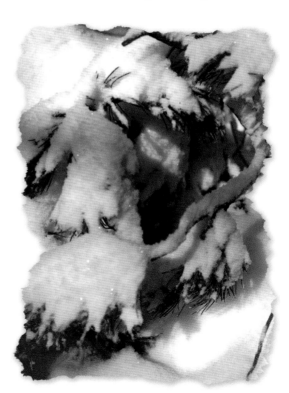

As you study snow, you will begin to notice how the light accents the texture and how the color of the light is relative to the ambient temperature and humidity. Most of all, you will begin to enjoy the intimate passages of time spent immersing yourself in this special seasonal blessing called snow.

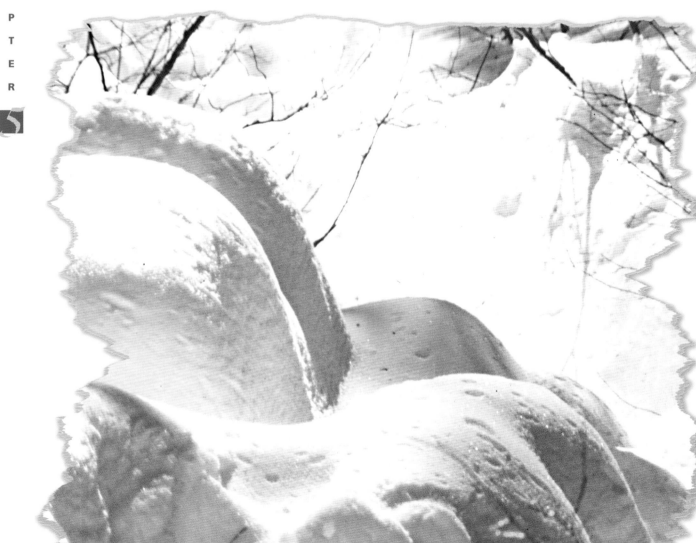

TYPES OF SNOW Snow changes during its life cycle. From the moment it starts falling to the last lingerings of spring melt, it transforms and affects whatever it comes in contact with. It affects visibility, depth of shadows, tree branches and twigs, the rocks and ground, streams and lakes, and our feelings.

The snow/rock photo above shows how a cold, crisp snow can remain almost in the condition in which it fell, if the weather over the next few days remains cold and dry. The photos on the right page show how moist snow, or snow that has been exposed to warmer or moister weather after it fell, looks heavier and exerts its weight on the branches and ground.

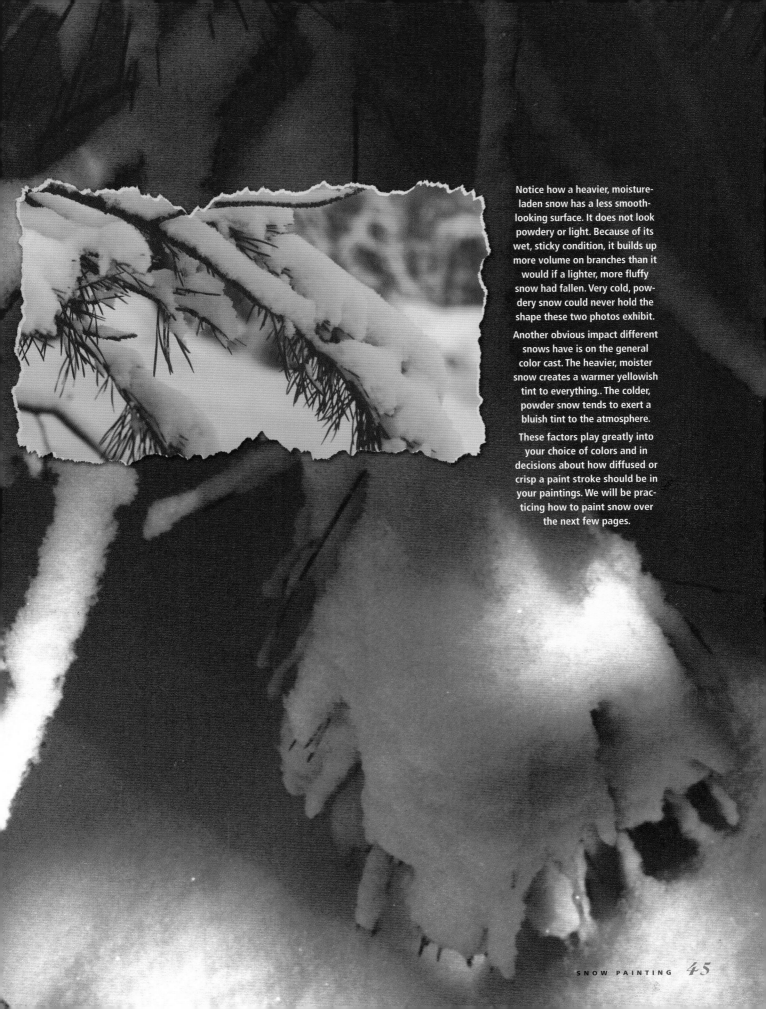

Notice how a heavier, moisture-laden snow has a less smooth-looking surface. It does not look powdery or light. Because of its wet, sticky condition, it builds up more volume on branches than it would if a lighter, more fluffy snow had fallen. Very cold, powdery snow could never hold the shape these two photos exhibit.

Another obvious impact different snows have is on the general color cast. The heavier, moister snow creates a warmer yellowish tint to everything.. The colder, powder snow tends to exert a bluish tint to the atmosphere.

These factors play greatly into your choice of colors and in decisions about how diffused or crisp a paint stroke should be in your paintings. We will be practicing how to paint snow over the next few pages.

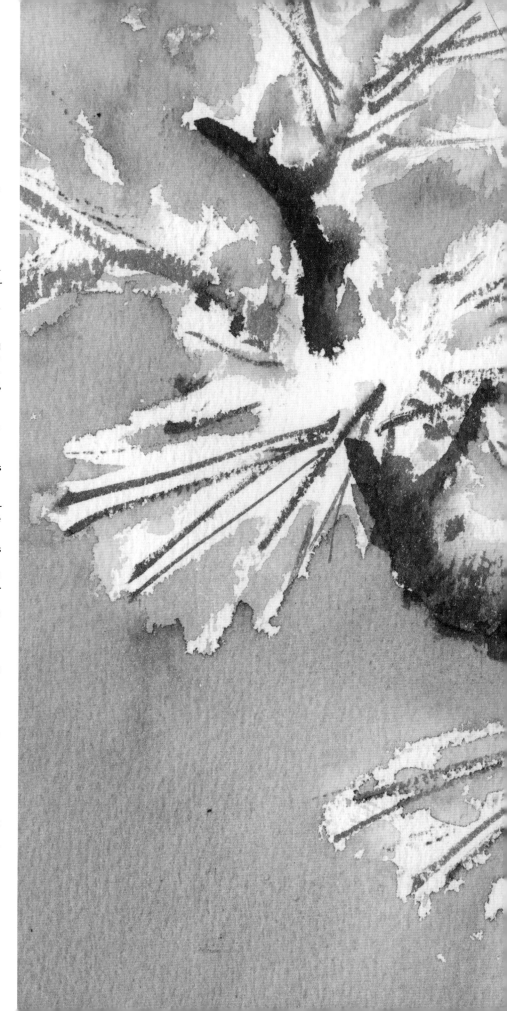

TECHNIQUES FOR PAINTING SNOW

PAPER Choose your paper depending on what you want the final painting to look like. A soft, un-sized paper will yield a diffused and darker stroke. A medium to highly sized rice paper requires a preliminary spray of water to yield soft, blended edges. Though I use sized rice paper for my best paintings, these demonstrations are done with a low-priced, medium-sized watercolor paper—it is easier to handle in the beginning.

USE OF WATER I spray my paper lightly, in preparation. I introduce more water with my brush when I want to diffuse or blend subtle areas as I paint. If you want to keep a crisper look, or harder edges, allow moisture to dry or don't do a preliminary spray at all, just introduce more water with the brush as you go.

MIXING PIGMENT Three options work well—in pallet wells, on the brush, or on the paper itself through applying multiple passes, or by layering sheets of color, with different pigments each time. We use all three for achieving a desired result. There are no hard-and-fast rules. Do what gets the job done.

TRICKS & TIPS This lesson shows two large, finished examples of the same exercise. The one on this spread shows the result of this lesson's steps outlined in the illustrations. The large, finished example on the next spread not only received a preliminary spray, but I also took a soft paper towel and blotted up moisture and pigment when I was done painting. Tissue is a good way to soften isolated areas, as well. Some artists sprinkle salt on the wet painting to create snow flakes, others will splatter white paint, thereby achieving the same effect. Practice and experimentation will open up your creative mind and heart to produce startling, finished, professional paintings.

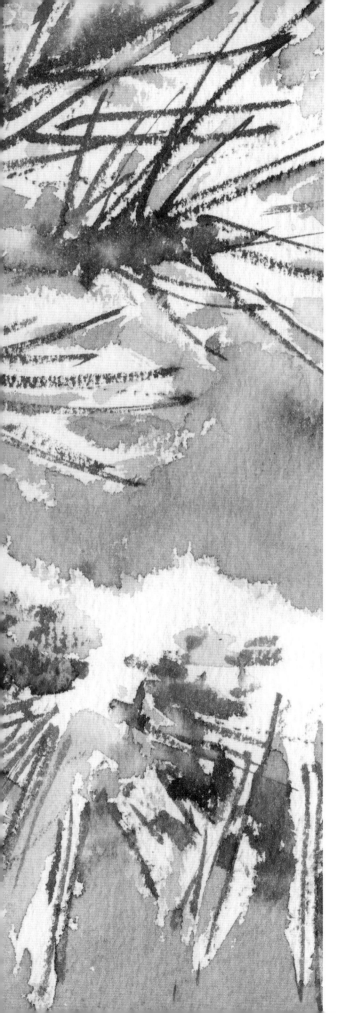

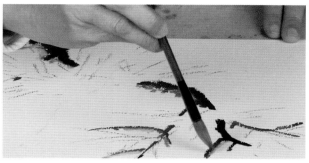

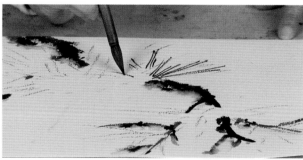

BRANCHES AND TWIGS

Mix the five shades of ink (#1 through #5). Prepare vandyke brown and burnt sienna pigments for mixing. Lightly draw in the major trunks, branches, and indicate the twigs. Remember your composition issues, such as angles, center focus area, and secondary lines that lead the eye.

MAIN BRANCH Soak lambswool or horse hair brush in water. Load with medium sienna and #3 ink, and then dip brush in brown with #4 ink. Angle and drag brush so darker pigment is on the underside of branch. Make thicker, more pronounced strokes where you want the focus to be. Make all strokes with inconsistent stops-and-starts. Make sure to leave areas branchless where snow will cover it. Come back into a branchless area and paint the underside of the branch where it will be visible

BRANCH SNOW AREAS Notice how the top of the branch is diffused where it will be softened by snow. This can be achieved by pressing the heel of the loaded brush hard (remember, you loaded water first). You can also go back in with a brush full of clear water and stroke the top of the branch to draw diffused pigment up to the snow.

MIXING PIGMENT Three options work well—in pallet wells, on the brush, or on the paper itself through applying multiple passes with different pigments each time. We use all three for achieving a desired result. There are no hard-and-fast rules. Do what gets the job done.

TWIGS Load a horse hair brush with brown with #2 ink, then load tip with brown with #5 ink. Try to make short wispy strokes that move away from the source. Make darker strokes in front, lighter pigment strokes in back.

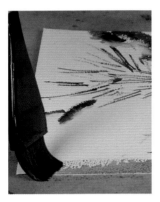

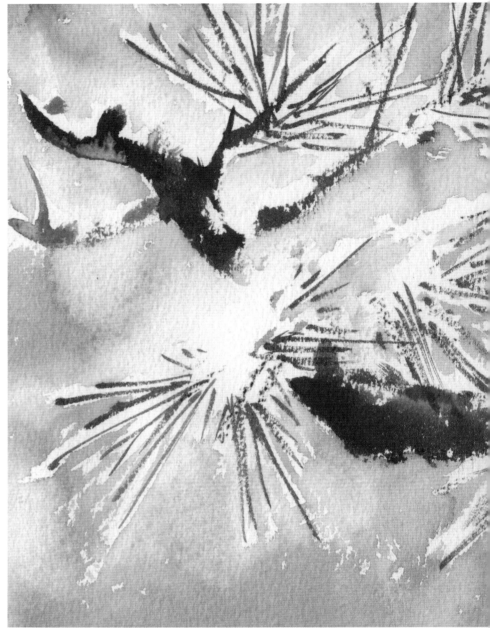

BACKGROUND WASHES

Same five shades of ink. Prepare indigo and cerulean blue pigments for mixing. The background helps define the branches and twigs, but most of all, it defines the snow by painting around snow areas. We will use at least two brushes for the background. Notice the big, flat brush for covering large areas and for having control over placing pigment in tighter areas around twigs.

LARGE AREAS Load a wet, flat brush with indigo with # 2 ink, and then with cerulean blue. Start filling in the larger background areas allowing the paint to flow wet.

SMALLER AREAS With the same brush and the same loading recipe, start to rough in the tighter areas, around the twigs. Do not get too close; you will come back with a smaller, pointed brush later.

BRANCH DEFINITION Be sure to take your horse hair brush, loaded with burnt sienna, and then dipped in brown with #5 ink. Apply this to the bottom of branches for shadowing. The paper should still be wet enough to allow this to blend into the already existing branch pigment in places.

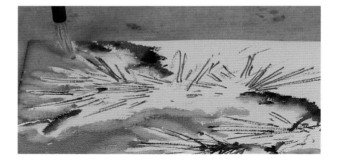

DEFINING THE SUBJECT
Our objective is to diffuse where we don't want focus, and to define with darker contrast or harder lines where we want focus.

PAINT AND/OR WATER Notice how the use of two brushes can make it look more natural. Use water to soften edges and pull pigment into areas. (Do not be afraid to use clear water to help you move paint around.) Also notice the use of darker pigment and less water to harden some edges of the snow. Remember, snow usually lands on the top of branches, twigs, and objects.

DIFFUSING SNOW When you want to create a very soft, gradated snow that depicts shape from light creating shadows, you can control this by taking a brush and loading it with water and adding a very light tint of blue pigment to the tip. Angle the brush so the tip is at the bottom of the snow, and the brush heel is at the top of the snow.

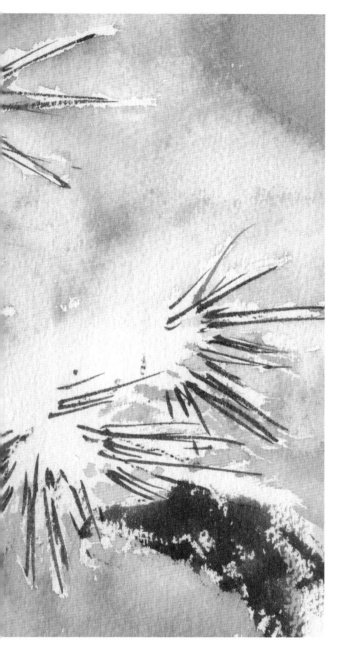

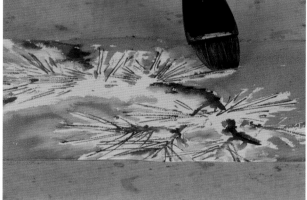

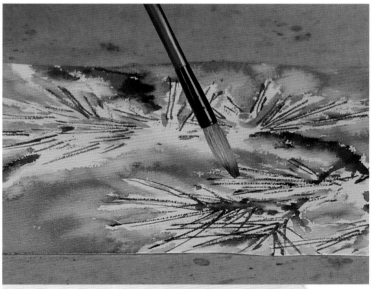

DEFINING SNOW Be careful about diffusing and blending the top of snow areas into the background. Unless you are painting a snowfall scene, snow generally looks relatively distinct against its background, whether the background is sky, bushes, other trees, or more snow (see photo of snow and rocks on page 44).

FINISHING DETAILS Load a small, pointed brush with brown with #5 ink. Apply deliberate and random strokes to places that need more detail—the underside of branches, twig tips, knot holes, and bark. Also, have medium brush loaded with a light shade of blue and apply dry brush strokes to texture the snow. You may also need to use some tissue to blot up pigment in areas you want to diffuse or blend, or in areas that have an unwanted hard edge where two strokes of paint ran into each other and dried before you could get to it with your brush.

PUTTING IT ALL TOGETHER

YOU HAVE completed all the steps that are performed in snow painting. Combining the birds into the branches, though it seems intimidating, is really as easy as what you just did. Merely treat the bird as another object placed into the scene of branches, twigs, snow, and background. Be sure to observe how other artists have handled the subjects you are interested in. There are many finished pieces in the Gallery Section of this book. With practice, it will all make sense and come together.

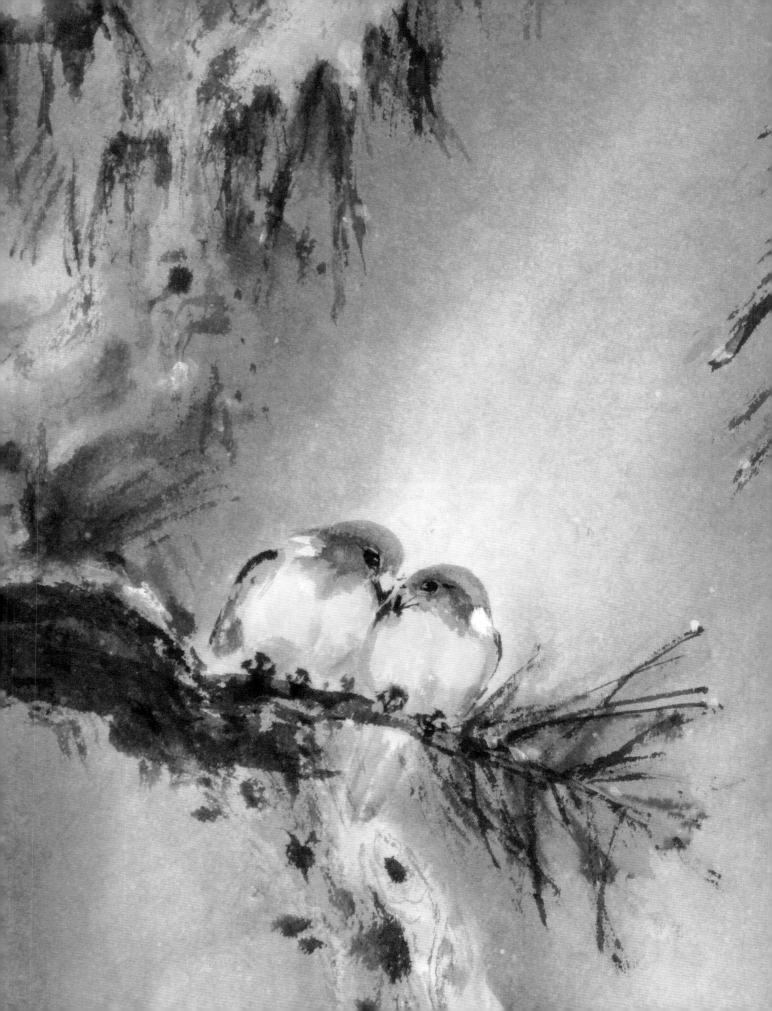

Gallery

AS AN ARTIST, I have come to love and appreciate nature and all it has to offer. The selection of paintings presented on the following pages were chosen from a lifetime of painting activity—culled from some 250 finished pieces in the winter/snow series. These paintings not only represent the best of my collection, they represent memories of experiences filled with wonder and excitement. They also help to stress the importance of getting out in nature and feeling the wind, the sun, and the temperature while feasting your eyes on nature's bounty. There should be no doubt in your mind that the only way to capture the scenes presented here is to be awestruck by what you see when personally observing nature. My hope is that you will be able to "see" what I "see" in these paintings.

The gallery contains paintings of blue jays, snowbirds, quail, trees, snow, lakes, villages, mountains, waterfalls, a chipmunk, and general landscape scenes. Some scenes are sunlit, some are muted with fog or snowfall. Some are very narrow in depth and only allow the viewer to see several feet into the scene, while some, like this round painting over Lake Tahoe, allow the viewer to see many miles.

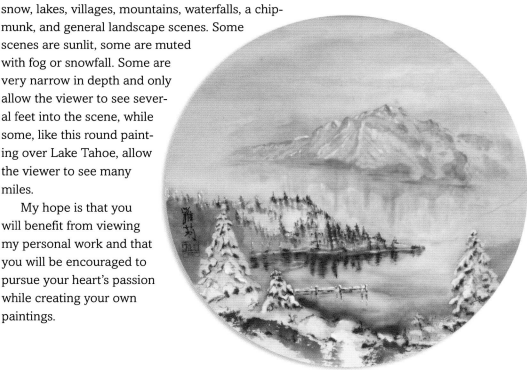

My hope is that you will benefit from viewing my personal work and that you will be encouraged to pursue your heart's passion while creating your own paintings.

Some paintings are available as
Fine Art Reproductions.
Books and paintings may be ordered by calling
1.866-711-7005, or online at: www.rosemary-art.com

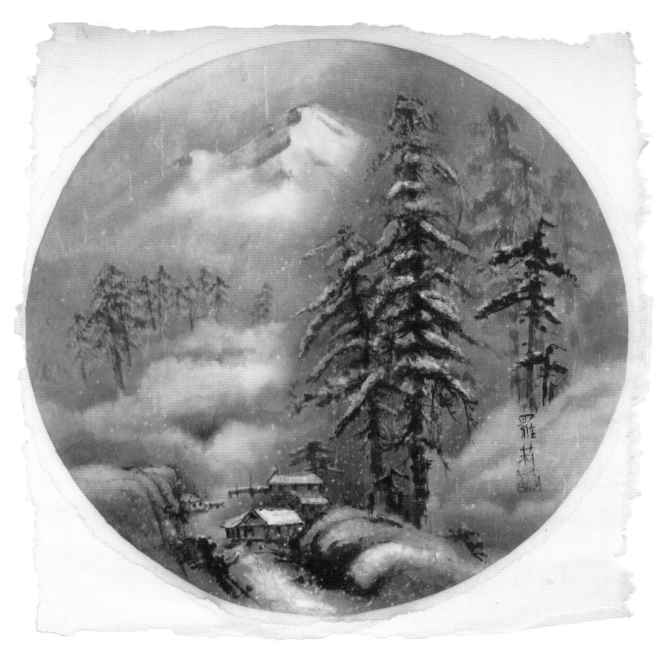

PYRAMID PEAK & CABINS
1980

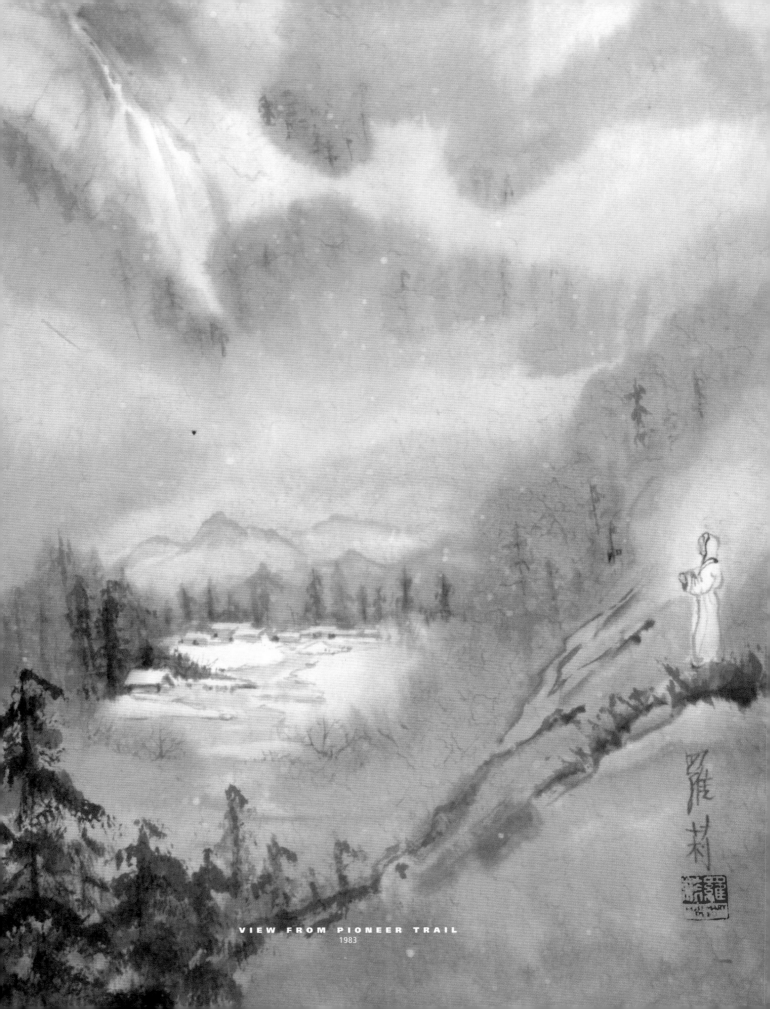

VIEW FROM PIONEER TRAIL
1983

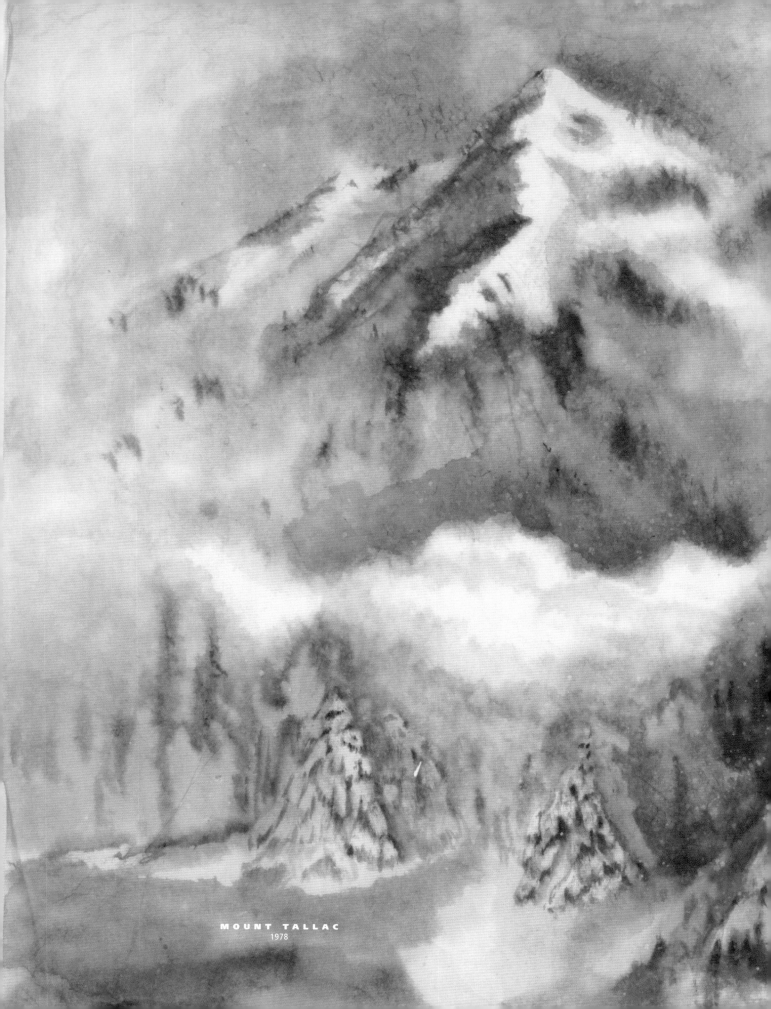

MOUNT TALLAC
1978

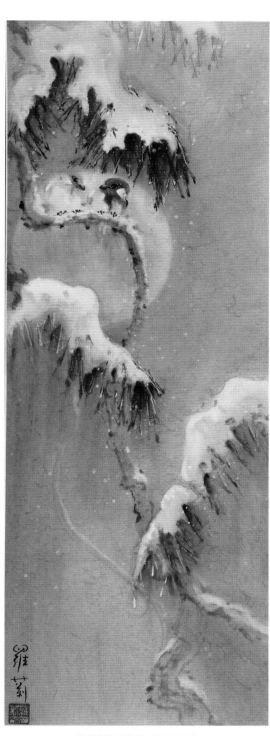

EVENING VISIT
1979

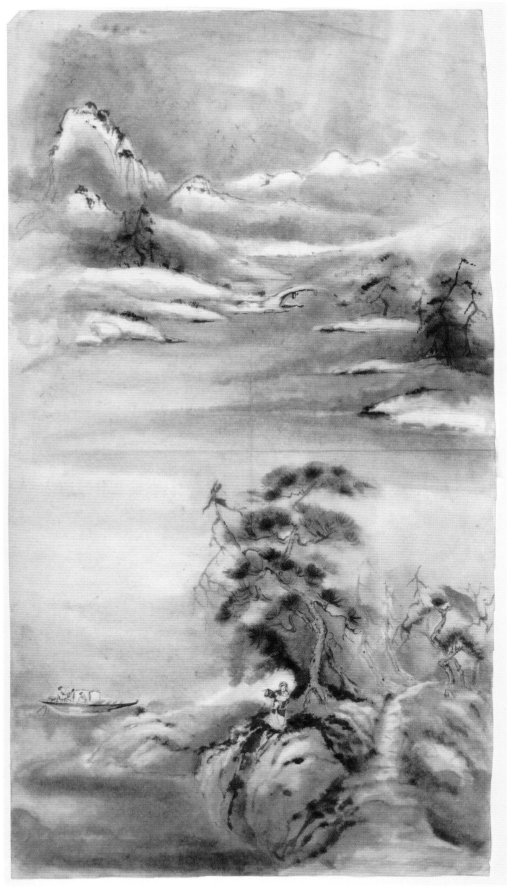

CHINESE LAKE
1985

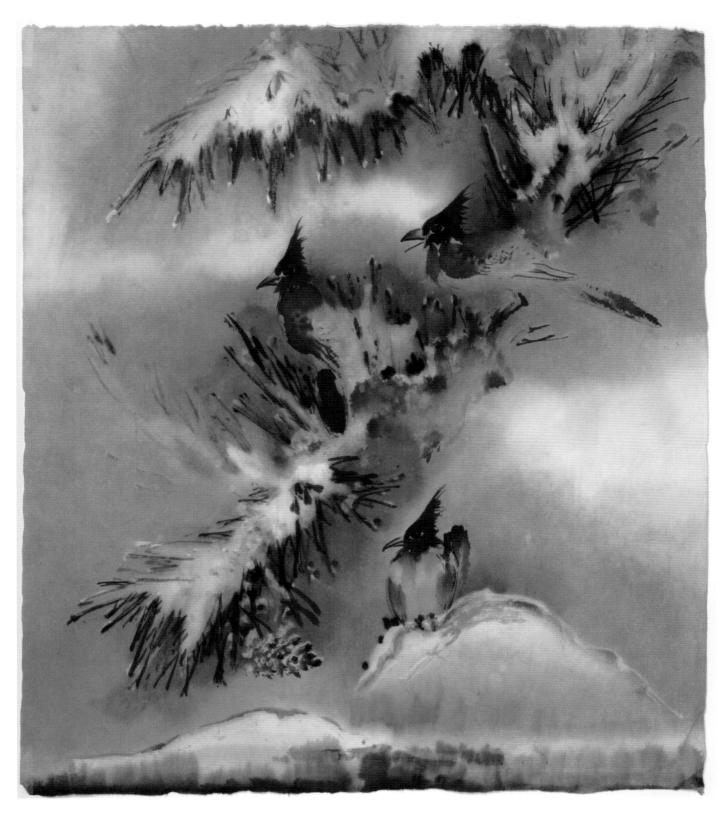

A BREAK IN THE STORM
1981

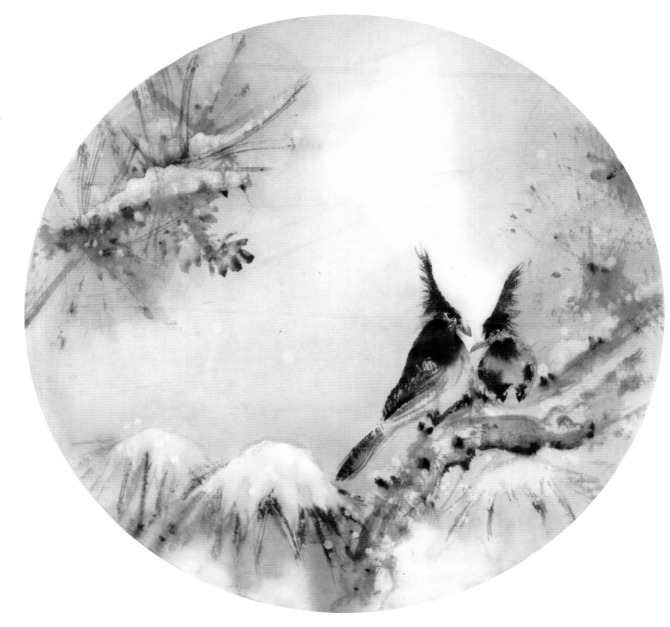

THOUGHT YOU'D BE HERE
1985

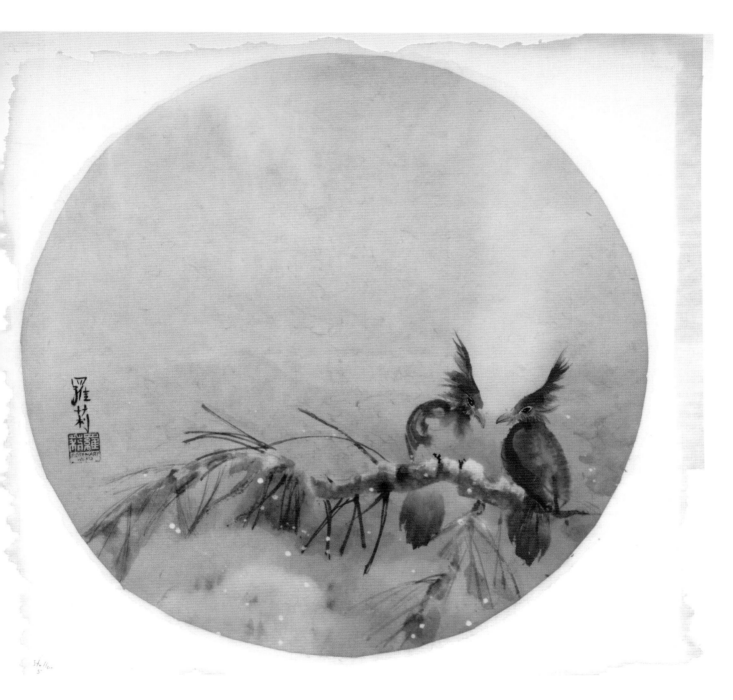

TWO JAYS ON BRANCH
1979

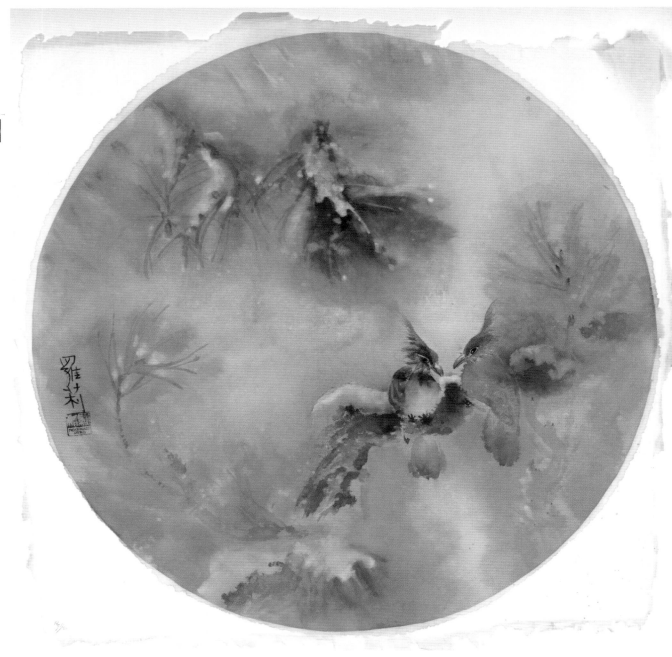

RESPITE ON SNOW BRANCH
1984

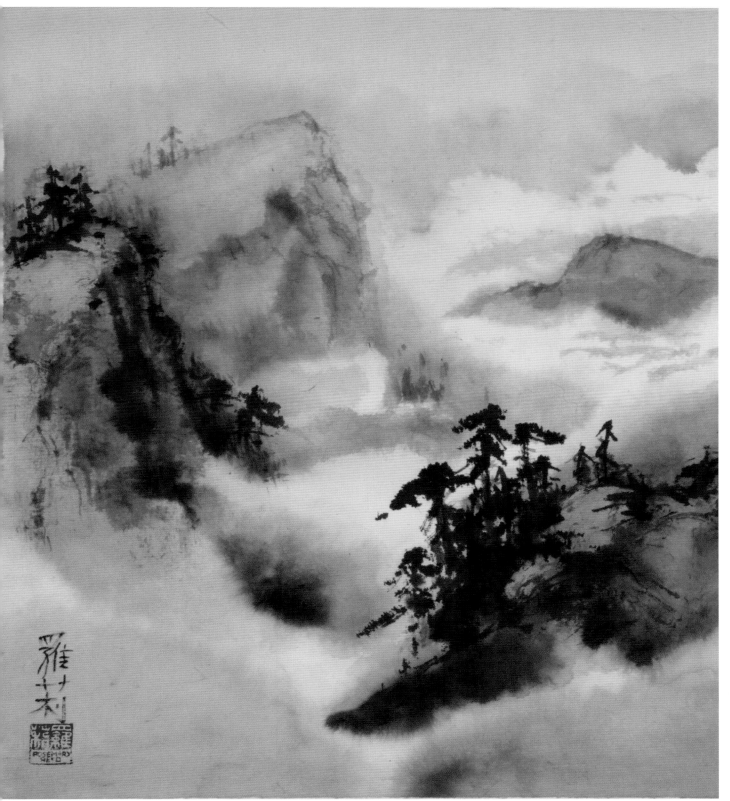

MOUNTAIN SANCTUARY AND FOG
1986

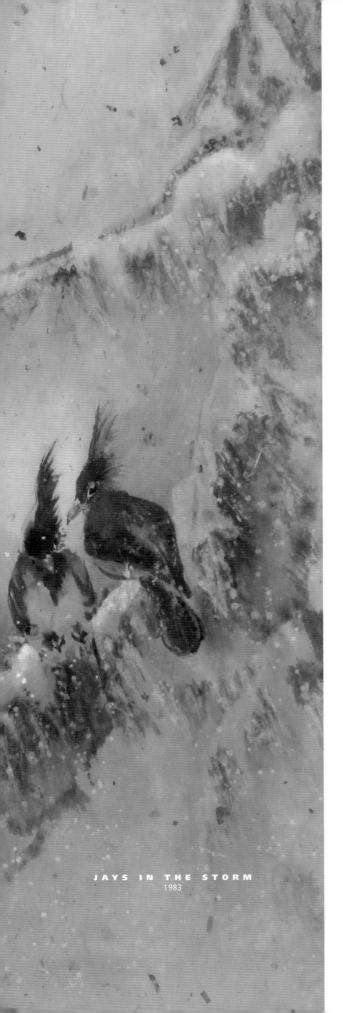

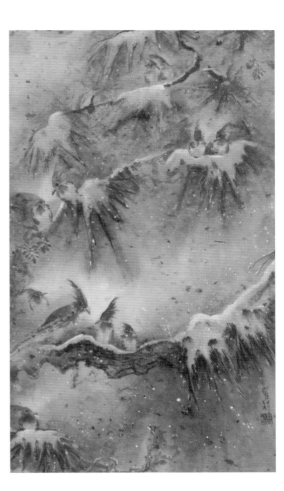

FAMILY CONVERSATION
1983

JAYS IN THE STORM
1983

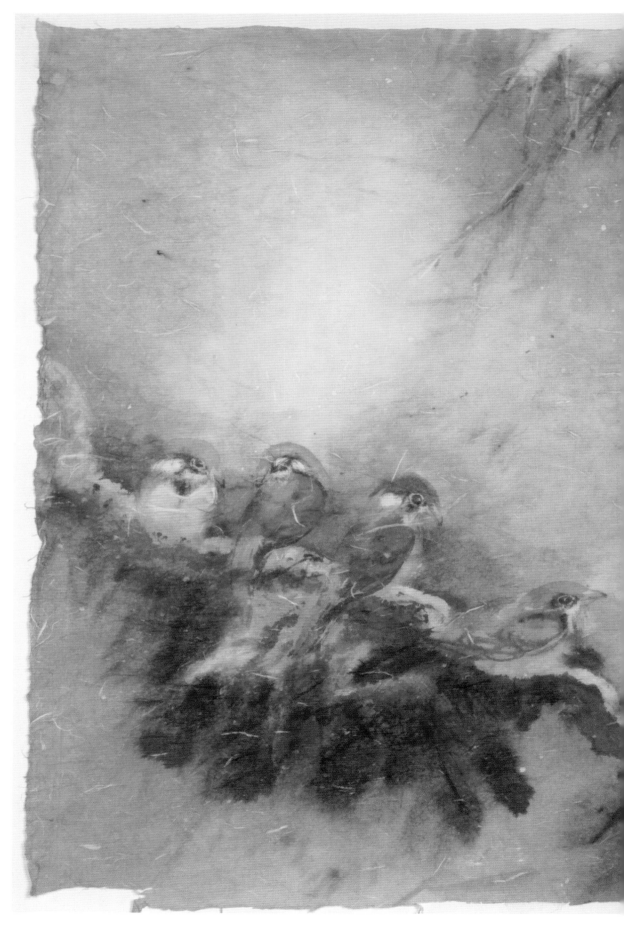

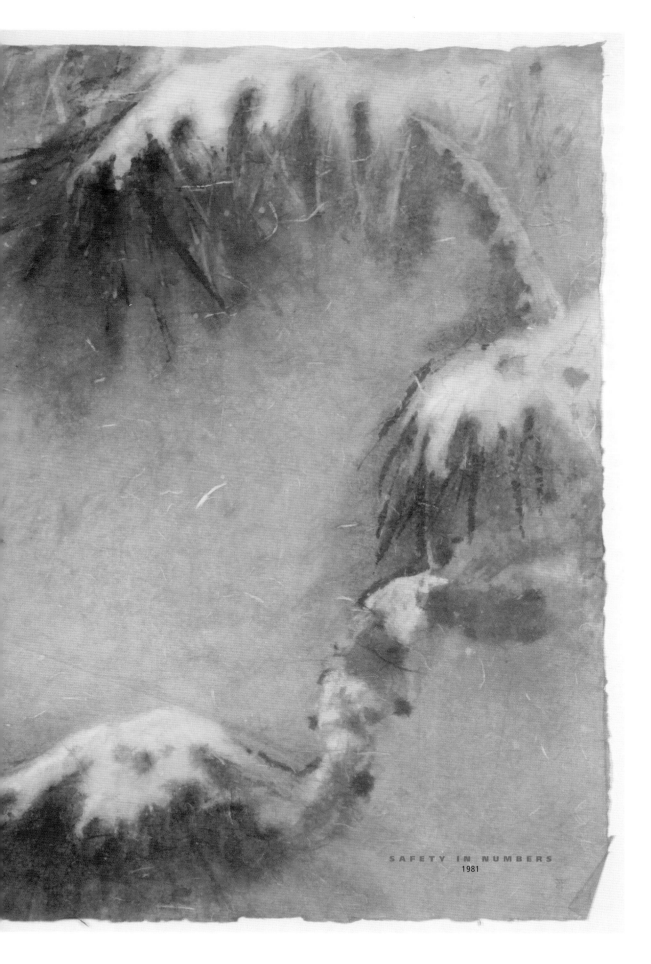

SAFETY IN NUMBERS
1981

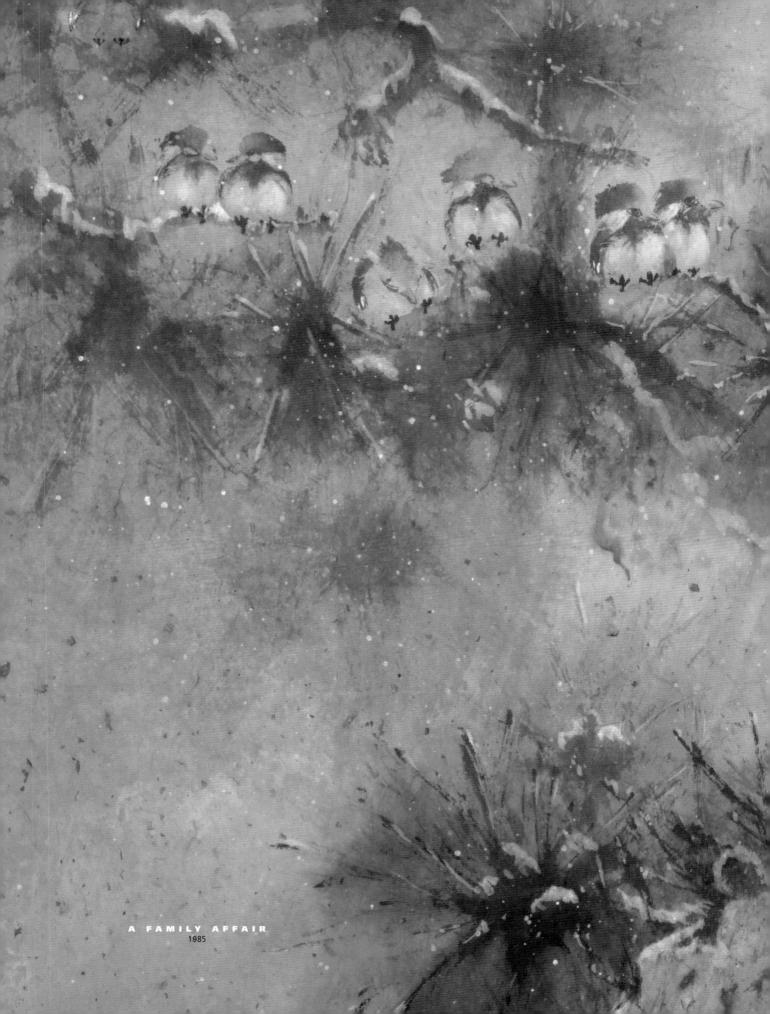

A FAMILY AFFAIR
1985

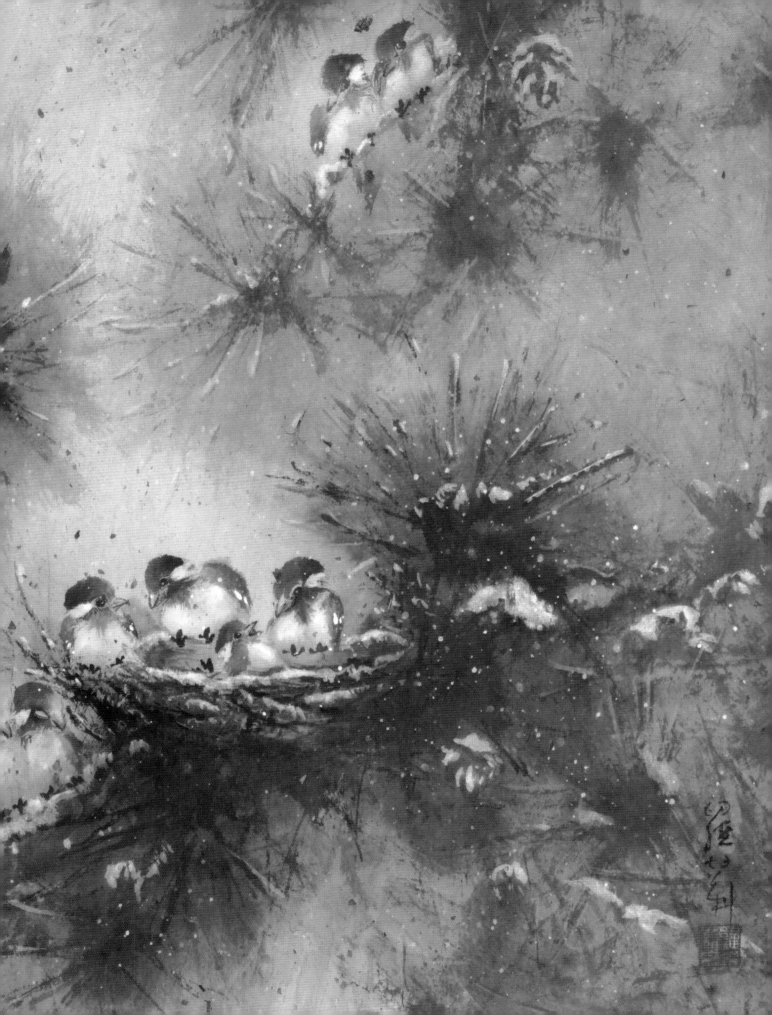

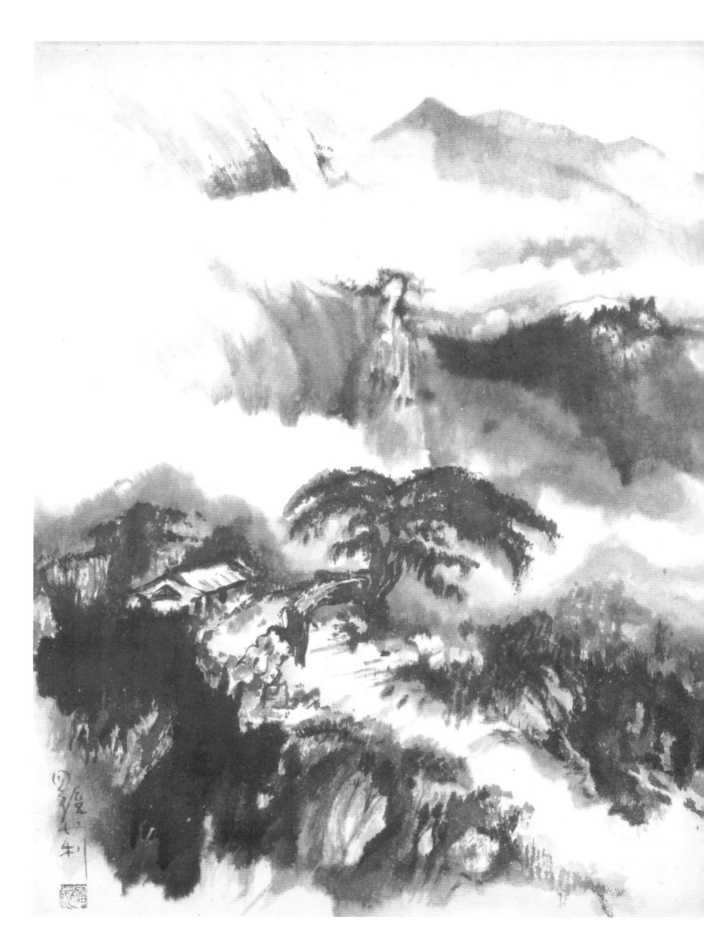

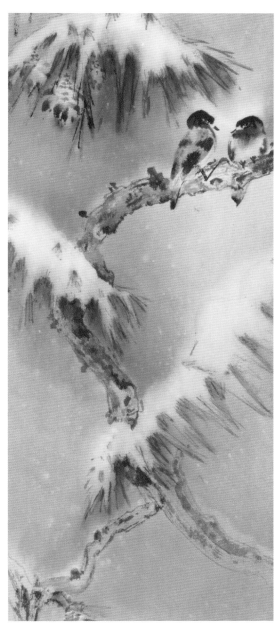

SNOWBIRDS
1985

FALLS, MOUNTAIN & CABIN
1991

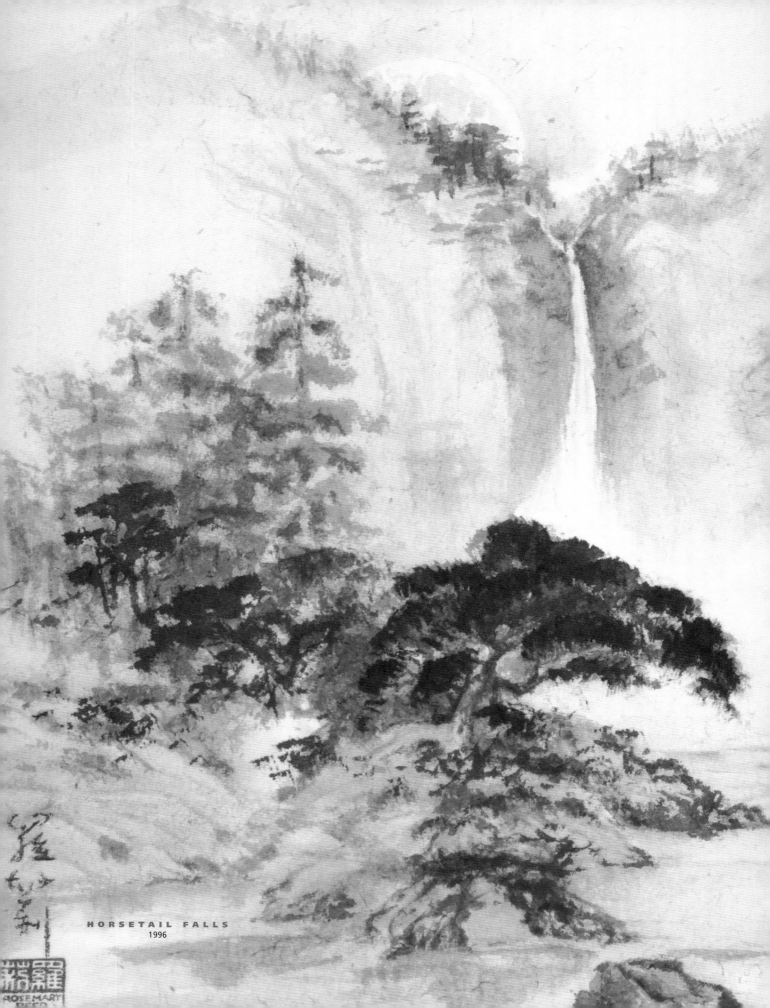

HORSETAIL FALLS
1996

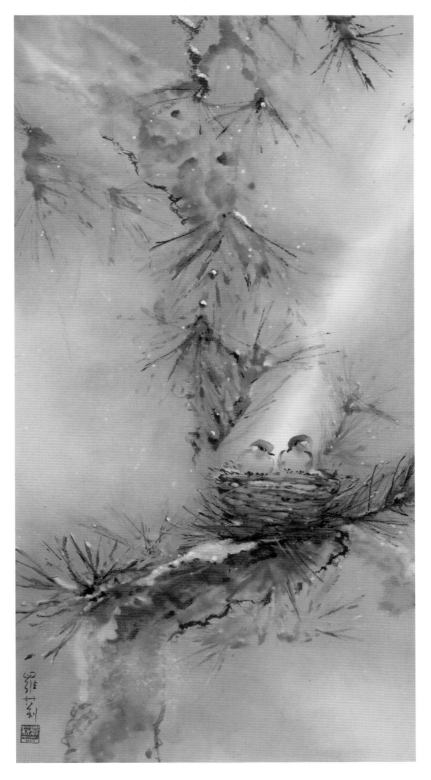

LOVE NEST
1987

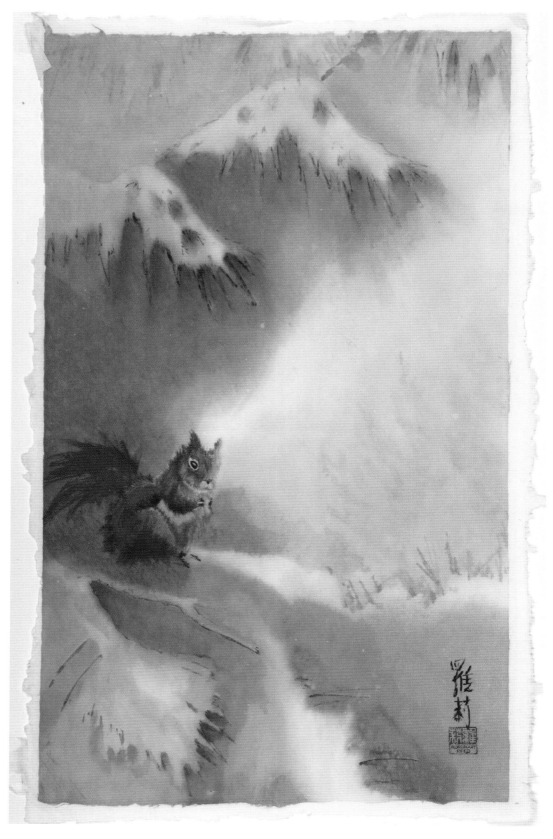

SQUIRREL
1984

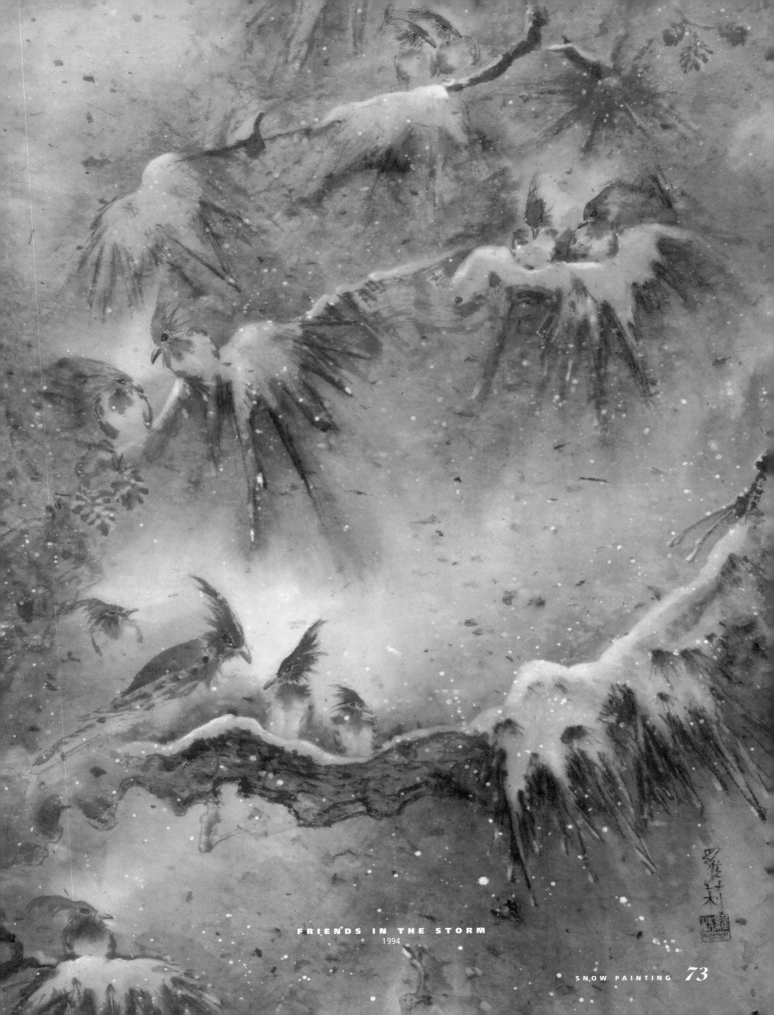

FRIENDS IN THE STORM
1994

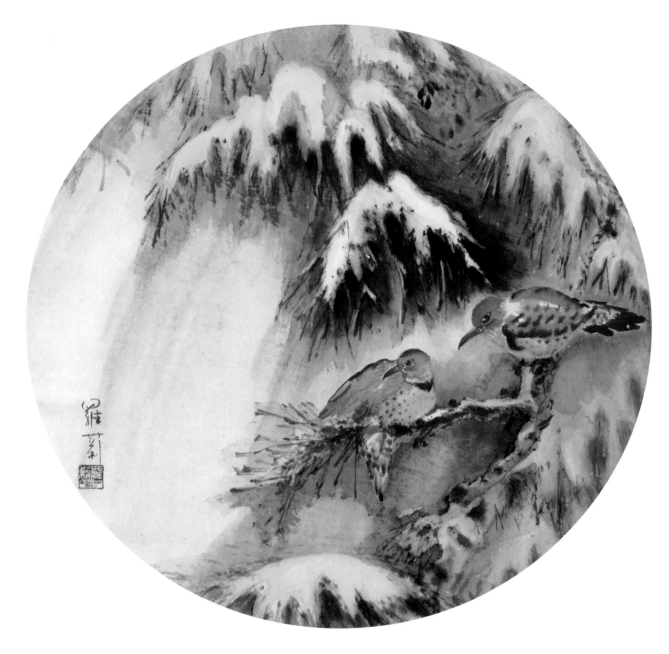

WAITING IT OUT
1989

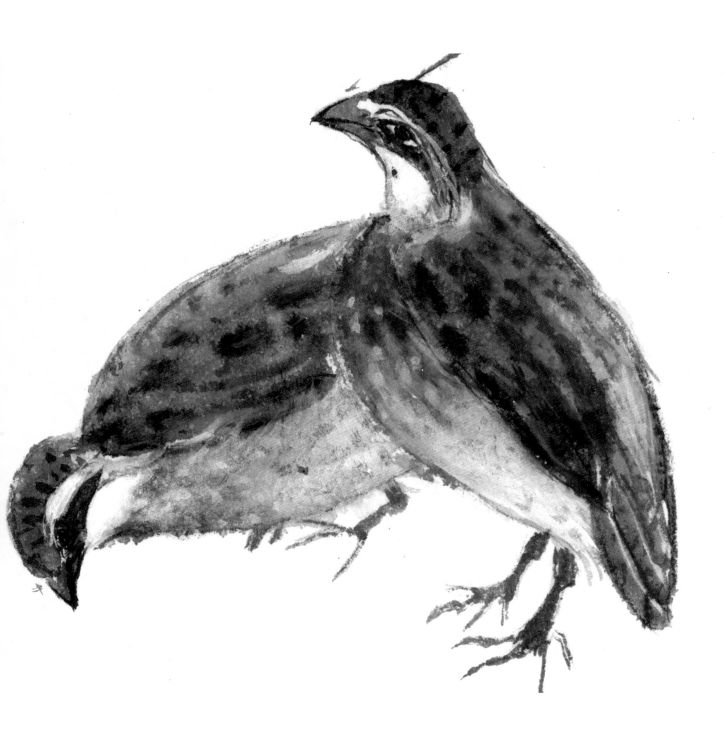

QUAIL
1983

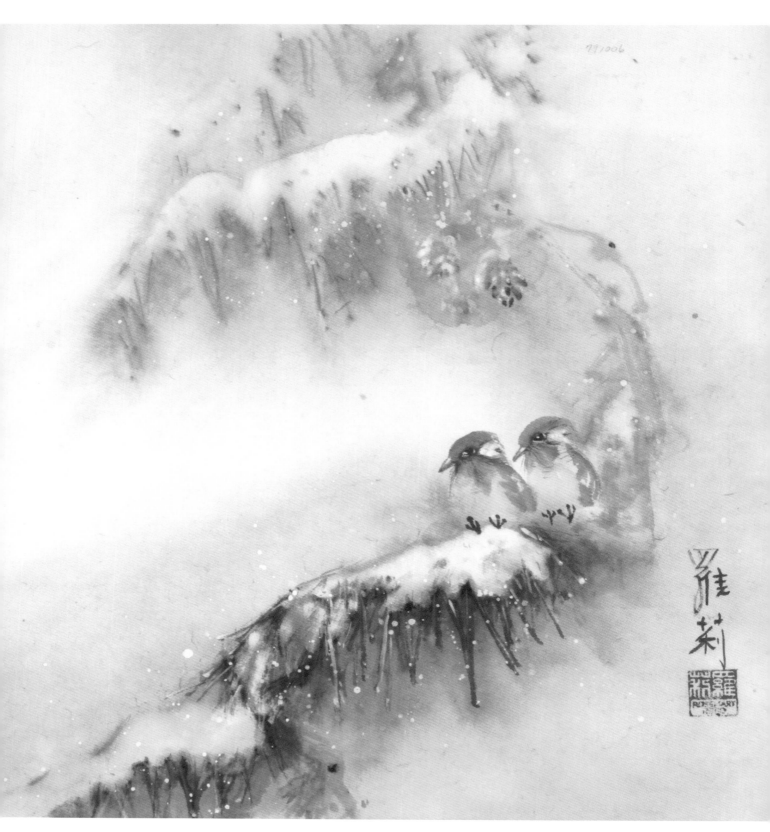

INTIMACY AT NOON
1997

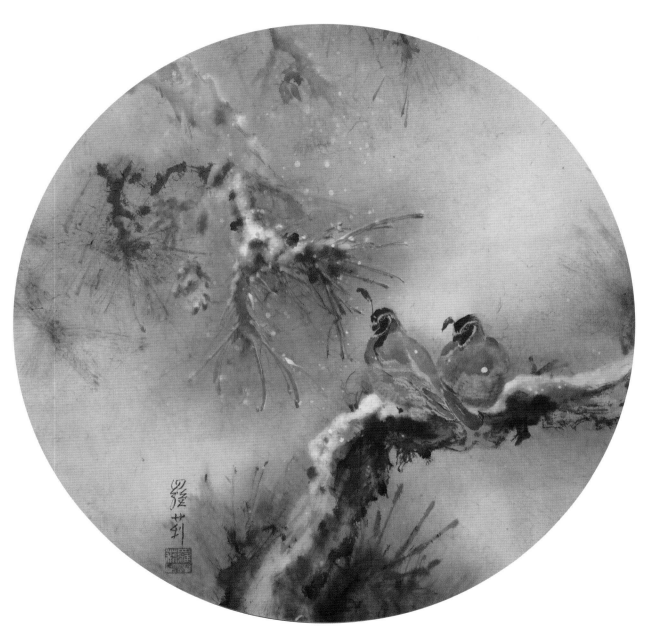

QUAIL COUPLE
1993

The artist, Rosemary Reed, 1979

About the artist

ROSEMARY REED has spent her entire adult life pursuing painting and drawing. A more correct statement would be that Rosemary has spent her life enjoying and loving the nature she lives in by interpreting it and transposing it into the most beautiful pieces of art possible.

Rosemary was born in Morgan Hill, California, in 1929. She has spent her life in California—a state with enough stunning, natural landscapes and seascapes to inspire her creativity with its beauty. Rosemary and her husband, Calvin, raised a family while living in Sacramento, California, where she graduated from California State University. In 1976 she earned her real estate license and practiced in the industry for decades.

She continued to pursue her interest in art by studying under the mentorship of a renowned and highly creative artist of the traditional Chinese style.

Rosemary has always had a desire to teach art. As a result, she developed lessons and material for books that would teach Chinese brush painting techniques to amateur and intermediate-level artists. She has also studied and practiced in the Western watercolor school tradition, and this background comes through in her teachings and style of painting.

Rosemary and her husband, Calvin, loved to ski and owned a cabin in the Lake Tahoe area. Rosemary also owns a home in Pebble Beach, near Carmel By The Sea, on the California coast. It was in these getaway sanctuaries that she infused her mind and soul with the visual material for her paintings. When Rosemary's paintings were moved from her Sacramento home in 2005, over 1,000 works of art were found. She was not even aware that she had painted so much.

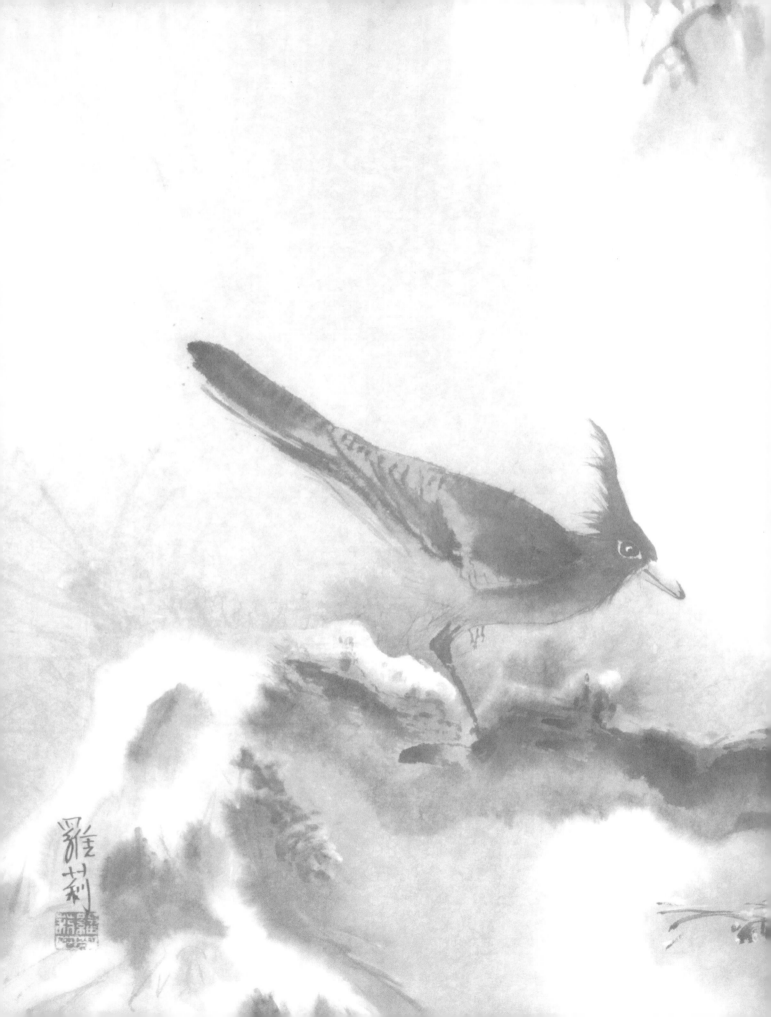